A–Z

OF

THE ISLE OF ANGLESEY

PLACES - PEOPLE - HISTORY

Warren Kovach

AMBERLEY

First published 2020

Amberley Publishing
The Hill, Stroud, Gloucestershire, GL5 4EP
www.amberley-books.com

Copyright © Warren Kovach, 2020

The right of Warren Kovach to be identified as
the Author of this work has been asserted in
accordance with the Copyrights, Designs and
Patents Act 1988.

ISBN 978 1 4456 9559 4 (print)
ISBN 978 1 4456 9560 0 (ebook)

British Library Cataloguing in Publication Data.
A catalogue record for this book is available
from the British Library.

Typesetting by Aura Technology and Software
Services, India. Printed in Great Britain.

Contents

Introduction

The attractions of Anglesey are innumerable and its history rich. Many books have been written about the island for locals and visitors hungry to learn more about its charms.

I've previously written two books about Anglesey: *Anglesey Through Time* and *Anglesey in 50 Buildings*. In these each page or section focuses on individual places or buildings and the stories that they can tell us about the island. For this book I aim to focus more on broader topics, which will reflect the wide range of delights of the Isle of Anglesey.

Many of the alphabetical chapters highlight certain types of buildings, such as churches and chapels or lighthouses, which describe their importance on the island and show some of the more interesting examples. Other sections focus on people, either the large landowning families (such as the Bulkeleys), or prominent individuals (including Christmas Evans and Kyffin Williams). The richness of the natural world on the island is addressed in the Geology and Nature Reserves sections, and the economy and social structures are covered in sections like Industry and Fairs and Markets.

Every one of these topics deserves a whole book of their own, so distilling the stories down to around 700 words each has been a challenge. However, I hope that this book will give you a taste of the unique history of our beloved isle, and encourage you to investigate more.

Amlwch and the Copper Kingdom

Looming over northern Anglesey is a barren landscape. A hollowed-out hilltop, devoid of vegetation and exposing fantastically coloured rocks, is all that is left of what was once the heart of a massive industrial operation. This now quiet rural area, Parys Mountain, once supplied copper around the world.

Copper has been a valued metal for more than 10,000 years, and became particularly widely used in the Bronze Age, 6,000 years ago, when people learned how to combine it with tin and other elements to make it much harder – ideal for tools and ornaments. The well-studied Bronze Age copper mine on the Great Orme, Llandudno, has recently been shown (through chemical 'fingerprints') to have been the source of copper used in tools found as far afield as Sweden, Germany and France. The scientists also estimate that several hundred tonnes of copper were produced between BC 1600 and 1400 – enough to make almost half a million metal objects.

Archaeological evidence at Parys Mountain show that copper was also being mined here at that period, and it is known that Romans were also hunting the metal. Copper

The Great Opencast Pit at Parys Mountain, with the windmill tower at the top.

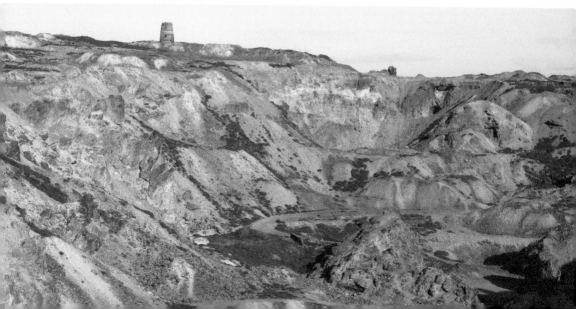

A piece of copper cake found near Parys Moutain. (Courtesy of the PortableAntiquities Scheme)

cakes similar to those found in other known Roman copper mines have been found in the area, and round copper ingots bearing Roman inscriptions have been found around the island. But the largest mining operations didn't start until the eighteenth century.

The hill overlooking the north Anglesey landscape was once called Mynydd Trysglwyn. The name is thought to derive from the Welsh words *trwsgl* and *llwyn*, meaning 'a rough grove of trees'. In 1406 a man named Robert Parys the Younger was appointed by the Crown to collect fines from supporters of Owain Glyndŵr's revolt. As a reward for his services he was granted the land around Mynydd Trysglwyn.

By the eighteenth century much of the land in Amlwch parish, which includes Parys Mountain, was in the hands of two of the largest landowners on the island: Sir Nicholas Bayley of Plas Newydd and William Lewis of Llys Dulas. It was mainly poor quality farmland, but it was known that there could be copper in the area worth searching for. However, several attempts were found to be not commercially viable. In 1764 Bayley leased the Parys Mountain land to a Macclesfield mining partnership,

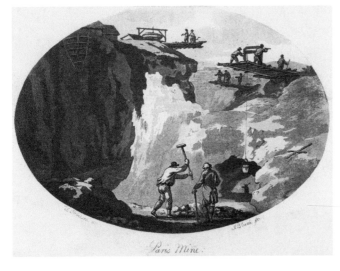

Mining at Parys Mountain. (National Library of Wales)

Messrs Roe & Co. They brought in a Derbyshire miner named Jonathon Roose to prospect for copper. He organised several teams of three to four miners to sink shafts on the mountain, and on 2 March 1768 one of these teams hit a rich seam of copper ore. The name of one of these miners survived, as there are records that Roland Pugh was awarded for his find with a bottle of brandy and a rent-free cottage for the rest of his and his wife's lives.

As the riches of Parys Mountain became apparent, disputes broke out between the landowners. The location of exact boundaries between their various lands owned by the Plas Newydd and Llys Dulas estates was sketchy, and some of the land was jointly owned. Revd Edward Hughes, who had inherited Llys Dulas, brought in a legal advisor to help sort out the mess. The lawyer Thomas Williams (a great-great-uncle of Kyffin Williams – see p. 42) was able to organise leases for the land from both owners to an embryonic Parys Mine Company, of which he became a director. His business savvy allowed him to build up the company to the largest copper mine in Europe, making him the richest man in Wales and the 'copper king'.

The original copper veins were close to the surface, and thus were extracted through open-cast mining. Over 4.4 million tonnes of copper ore were mined – by up to 1,200 miners who were employed at its peak – over the next thirty years. This ore was shipped out through nearby Amlwch port. What once had been a sleepy fishing village rapidly turned into the second largest town in Wales and one of the busiest ports.

Eventually the easily accessible copper was mined out and the company began sinking shafts to get to the remaining veins deep underground. Initially miners would be sent down the shafts to bring up the ore, but by the 1870s they allowed the mines to flood, then pumped out the water into pits on the surface, where the copper would precipitate out to be easily collected. The mine finally closed in the early twentieth century. However, in recent years, as copper prices have risen, the company that now owns Parys Mountain, Anglesey Mining PLC, has been carrying out exploration and planning with a view to resuming mining operations.

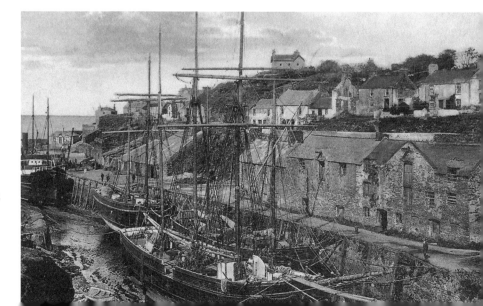

Amlwch Port, around 1915.

Bulkeley Family

Before the English conquest of North Wales by Edward I, much of the land on Anglesey was controlled by the royal house of Gwynedd and three of the fifteen Noble Tribes of Wales, those founded by Hwfa ap Cynddelw, Llywarch ap Bran and Gweirydd ap Rhys Goch. During this time Welsh law decreed that inherited lands couldn't be sold; they had to remain in the family, so continued to be controlled by these ancient families. However, post-Conquest, clever ways were found around these rules, and the more ambitious landowners began accumulating larger estates, either through the land market or through marriage. This applied to both native Anglesey families as well as outsiders.

One of these outsiders was William Bulkeley. Born in 1418 in Cheadle, into a prominent Cheshire family, he was the wealthy heir of a substantial estate. But seeking further fortunes, he settled in Beaumaris sometime before 1444. He soon worked his way into the local society by marrying Elin, the daughter of Gwilym ap Gruffudd. Gwilym, who

Henblas, drawn in 1869 just before demolition. (J. Stephens/Royal Commission on the Ancient and Historical Monuments of Wales)

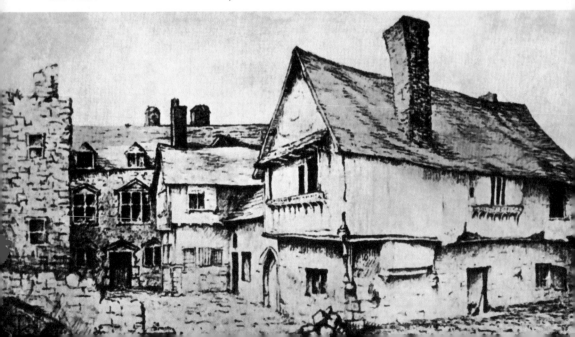

later anglicised his name as William Griffiths, was the owner of the Penrhyn estate, which covered much of north-east Anglesey as well the area outside of Bangor where the current Penrhyn Castle stands. His connection to this prominent family allowed Bulkeley to take up various offices, such as the king's serjeant-at-arms, deputy constable of Beaumaris Castle, and alderman of the borough. He also soon began buying up land. Between 1450 and 1490 he and his wife were involved in no fewer than thirty-five land transactions in Beaumaris, plus dozens of others around Anglesey.

William Bulkeley was most likely the builder of the family home of Henblas in Beaumaris. Standing on a large plot of land on Church Street, between the church and the current Market Square, Henblas was one of the finest houses on the island at the time. It had a H-shaped floor plan typical of English houses during this period, with a great hall in the middle. The two wings on either side housed parlours, a kitchen and other living rooms. It was the Bulkeley family home until 1618 when they built Baron Hill mansion on the outskirts of the town. The house gradually declined through the ages, until in the nineteenth century it was occupied by a dozen pauper families and was in serious disrepair. It was demolished in 1869.

Alabaster tomb of William Bulkeley and his wife Elin, in St Mary & St Nicholas Church, Beaumaris.

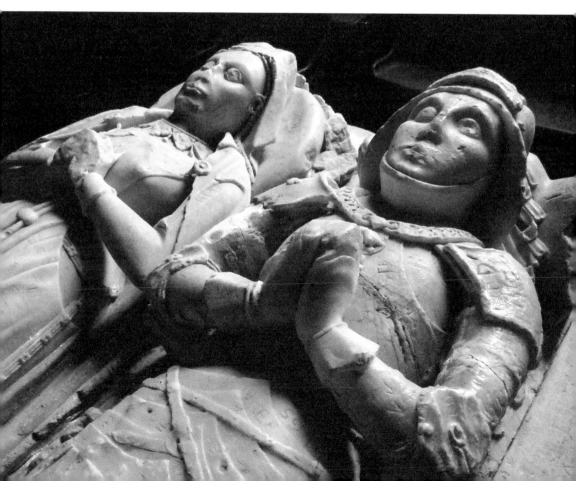

Fortunately, detailed descriptions and drawings of the house were done shortly before, preserving knowledge of this important building.

William died in 1490 and is buried with his wife in a fine alabaster tomb in Beaumaris church. His estate was divided between his several sons, but eventually the majority of it passed to the third brother Rowland. After his death in 1537 his son Richard inherited. He became a chancellor and chamberlain of the Crown for North Wales, as well as county sheriff and Member of Parliament, and was knighted around 1534. His son, grandson and great-grandson, were all named Richard, all MPs and holders of other high offices, and were all knighted.

The second and fourth Sir Richards also shared the indignity of being involved in adultery and murder scandals. Agnes, the wife of the second Sir Richard, had an affair with William Kendrick, 'a young gallant', and was accused by her stepson, the third Sir Richard, of poisoning his father. However, she was acquitted. The wife of the fourth Sir Richard, Anne, had an affair with their land agent Thomas Cheadle, and they were also tried for murder when Sir Richard died mysteriously. They too were acquitted.

The fifth Richard died without children, so the estate passed to his uncle Thomas Bulkeley. His ownership coincided with the Civil War, in which he supported the Royalists, and he was made a viscount, with the title being carried down several generations until the late eighteenth century when Thomas James Bulkeley was made a baron. Unfortunately, he died without issue. The estate was then inherited by his nephew Richard Williams, who was granted a royal licence to change his surname to Williams-Bulkeley. This name is carried today by the current owner of the estate, Sir Richard Thomas Williams-Bulkeley.

Baron Hill in 1906. (Courtesy of John Cowell)

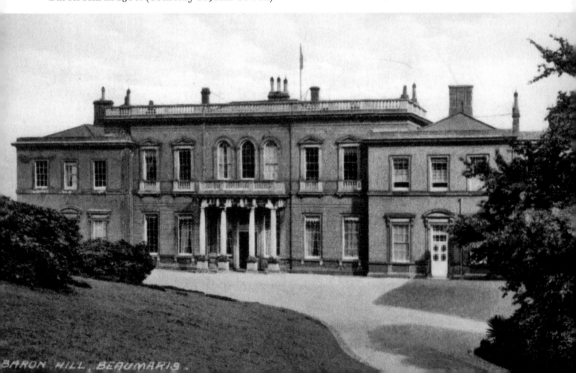

Baron Hill mansion, built by the third Sir Richard, was a grand house that was extended in 1776. But, by the early twentieth century it had become too expensive to maintain and the family moved to nearby Red Hill. Baron Hill was used to house Royal Engineers during the First World War, but later was extensively damaged by fire and is now an empty shell disappearing into the forest.

Since the main estate was passed on to just one son, the younger offspring sought opportunities elsewhere, and there are descendants of the Sir Richards who have become connected to other smaller estates around the island and elsewhere. The most notable was William Bulkeley of Brynddu, near Llanfechell. Born in 1691, he was a typical country squire, running his estate and being a Justice of the Peace. However, he was also a prolific diarist, and his two surviving diaries from 1734–43 and 1747–60 give us a unique insight to life in the eighteenth century on Anglesey. Each day, in over 1,000 pages of small, neat handwriting, he invariably recorded the weather and direction of the wind before going on to detail his daily concerns. Mostly this was to do with running the estate: when ploughing or harvesting began, wages paid to workers, prices of goods in the markets, etc. But he also recorded details of the goings on in the local community, court cases or church matters, and national and international affairs and politics. The diaries now reside in the Bangor University Archives. They have been digitised and transcribed so that anyone with internet access can easily consult them for historical research or just curiosity about life in that century. They can be found at the website bulkeleydiaries.bangor.ac.uk.

Edward VII (seated centre) visiting Baron Hill and Sir Richard Bulkeley (far left) in 1907. (Courtesy of John Cowell)

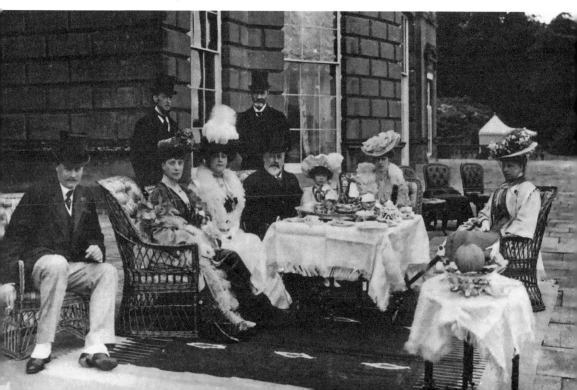

Churches and Chapels

Anglesey is dotted with dozens of small, ancient churches. Many of these old stone buildings were originally built in the twelfth to fifteenth centuries, and have often been renovated, expanded and rebuilt throughout the ages into the Victorian era. They usually replaced earlier structures built of timber and roofed with thatch. The early stone churches were also probably thatched, and were simple structures with earth floors and no pews – the worshippers would stand.

Church names in Wales often begin with 'Llan...', followed by the name of a saint. This is usually taken to mean 'church of', but more properly means 'enclosure'. These ecclesiastical settlements began in the sixth or seventh centuries as a hermit's cell enclosed within an oval or circular wall. Many of the older and more remote churches on the island, such as St Mary's in Tal-y-Llyn, near Dothan, or the ruined Hen Capel in Lligwy, still have rounded enclosure walls. They may once have been the centre of sizeable settlements of wooden buildings, but the abandonment of the village due to depopulation or the consolidation of communities have left them in splendid isolation.

St Mary's Church, Tal-y-Llyn.

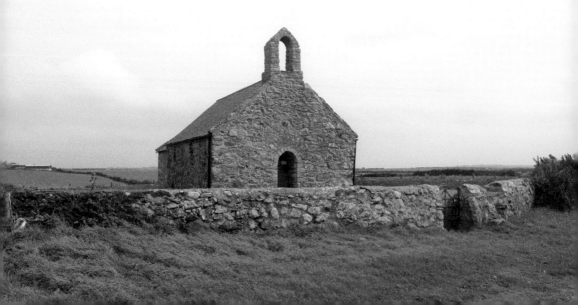

The Reformation and the Civil War in the sixteenth and seventeenth centuries saw upheaval in the religious landscape. The majority of the previously Catholic churches were now Anglican, and by this period were becoming more elaborate, with proper stone floors and roofing, and seating (box pews for the gentry, benches for everyone else). Many were expanded to accommodate the growing populations. In the nineteenth century a sizeable number of these churches underwent extensive modernisation, sometimes leaving little of the original medieval character. Shifts in population centres with the coming of new roads and railways meant that many new churches were built (such as those in Menai Bridge, Llanfairpwll, Llanidan, Cemaes and Valley), leaving the remote ancient churches little used or abandoned.

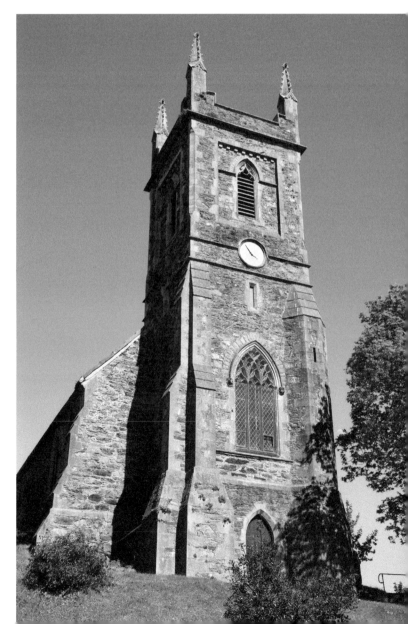

St Mary's Church,
Menai Bridge,
built 1858.

The rise of Nonconformist movements in the eighteenth century, such as Baptists and Methodists, led them to seek out their own places of worship. Originally meeting in private homes, barns or outhouses, as their followings grew they began developing their own chapels, with an architectural style very different from existing churches to reflect their different styles of worship. The preacher's pulpit became the focus

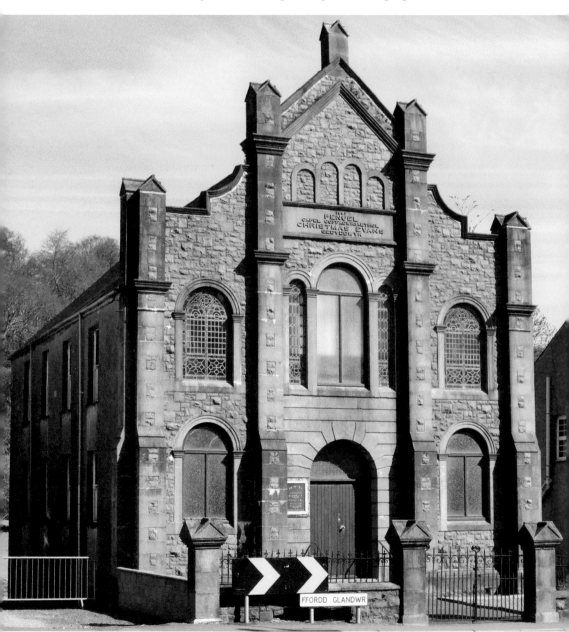

Capel Penuel, Llangefni, built 1887.

of attention, with galleries of benches to accommodate the worshipers. Externally, the chapels often were based on classical design elements, which were popular at the time, with columns, pediments and balustraded parapets common. On Anglesey around seventy-three chapels were built between 1800 and 1840 alone. Today every village or hamlet has at least one chapel, some still in use, with many converted to other uses, and many more sadly deteriorating.

The building of new churches didn't stop in the Victorian era. In particular, almost all of the Catholic churches on the island were built in the twentieth century – many with an unusual modern design, such as Our Lady Star of the Sea & St Winefride in Amlwch.

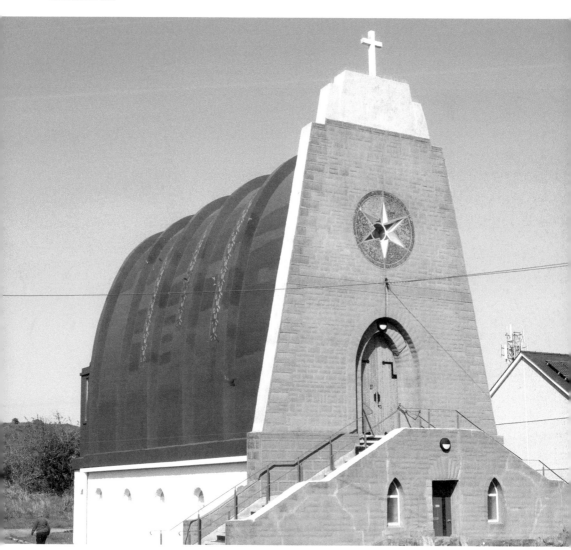

Our Lady Star of the Sea & St Winefride, Amlwch, built 1937.

Druids

Anglesey has been linked to the Druids in popular memory for centuries. The Roman historian Tacitus famously described Suetonius Paulinus and his troops facing the Druids across the Menai Strait: 'By the shore stood an opposing battle-line, thick with men and weapons, women running between them, like the Furies in their funereal clothes, their hair flowing, carrying torches; and Druids among them, pouring out frightful curses with their hands raised high to the heavens, our soldiers being so scared by the unfamiliar sight that their limbs were paralysed, and they stood motionless and exposed to be wounded.' The Romans eventually won the battle, subdued the Druids, and cut down their groves of sacred oaks.

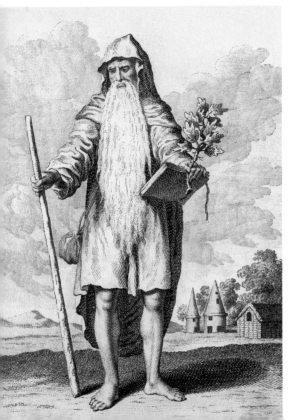

The Chief Druid – drawing from Thomas Pennant's *A Tour in Wales*. (Courtesy of the National Library of Wales)

Tales of the Druids feature heavily in early histories of Anglesey, such as Henry Rowlands' *Mona Antiqua Restaurata*, published in 1723, and Angharad Llwyd's Eisteddfod-winning essay *A History of the Island of Mona* from 1832. However, it is difficult to tell how accurate their descriptions are since the Druids themselves left no written records. The only contemporaneous sources of information about them are from their enemies, the Romans, most notably in Julius Caesar's *The Gallic Wars* and the writings of Pliny the Elder. These give good descriptions of the Druids, but some of it may tend towards misinformation.

Druids are generally thought of as Celtic priests, but they were also teachers, folklorists, judges, political advisors and medical practitioners. Along with the other upper class of Celtic society, the warrior aristocracy, they ruled over the common man. The Romans describe the Druids as presiding over ceremonies of human sacrifice, most notably the practice of building a giant wicker man, within which a number of people were sacrificed as the effigy was set alight. Although some sacrifice probably did take place, as evidenced by the finds of bodies bearing ritualistic wounds preserved in bogs in Ireland, England and Scandinavia, the Romans probably overemphasised the extent of it for propaganda purposes.

One common misconception is that the numerous standing stones and cromlechs and other monumental structures, both on Anglesey and around Britain (Stonehenge included) were associated with the Druids. The cromlechs were even often called Druid's altars, because the flat horizontal stones forming the top of what we now know to be the burial chambers were seen as the equivalent of the Christian altar. These in fact predate the arrival of the Celts and Druids by millennia.

The tradition of the Druids lives on today in two forms. In 1792 a Welsh scholar and poet living in London, Iolo Morganwg (born Edward Williams), organised an event in Primrose Hill to celebrate Welsh culture and literature. He called this the Gorsedd of Bards, claiming it followed on from the ancient Druidic rites. In the nineteenth century this evolved into the Eisteddfod, a series of cultural events at both the local and national level, where the language, music, literature and other achievements of the Welsh people are celebrated. Members of the Gorsedd today, encompassing prize

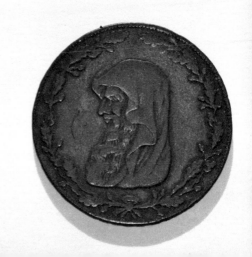

Druid Head Penny, also known as the Anglesey Penny, a token produced by the Parys Mountain Copper Works for paying their workers.

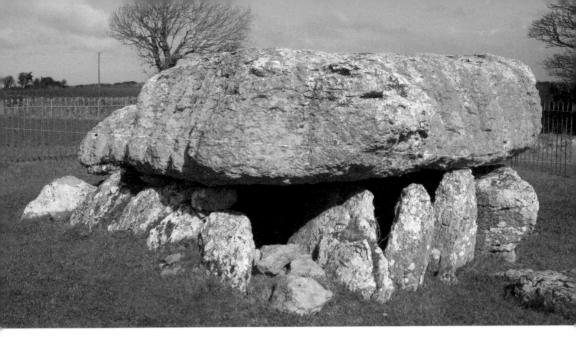

Cromlech at Lligwy, a 5,000-year-old Neolithic burial chamber, *not* a druid's altar.

winners from previous *eisteddfodau* as well as community figures and notables in various fields of endeavour, are known as Druids.

In recent decades, as the dominance of the traditional churches in community life have declined, but people still look for ways to express their spirituality, various forms of shamanic and druidic practices have flourished. In Britain they are best known for their marking of the solstices at Stonehenge, but an active group on Anglesey, the Anglesey Druid Order, holds local celebrations, particularly at the Bryn Celli Ddu burial chamber, as well as offering training courses in Celtic mythology and spirituality.

A Gorsedd stone circle near the Menai Suspension Bridge, used for ceremonies during the 1965 Anglesey Eisteddfod.

E

Evans, Christmas

From the prehistoric burial tombs, through the oak groves of the Druids and on to the early Christian monasteries, Anglesey has always been an island with a strong spiritual presence. The sixteenth-century Reformation and the seventeenth-century rise of Puritanism brought turmoil to the Christian world throughout the UK, including Anglesey, leading to the waves of Nonconformism that swept Wales in the eighteenth century. A large number of preachers visited the island, including the Wesley brothers, founders of Methodism, and chapels sprang up in every town and village. Among all the preachers at these chapels, one of the greatest was Christmas Evans.

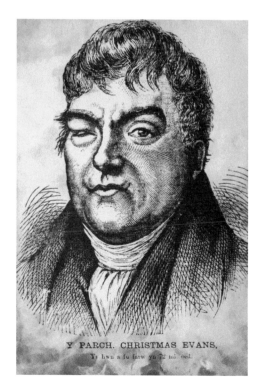

Y PARCH. CHRISTMAS EVANS,
Yr hwn a fu farw yn 72 ml oed.

Christmas Evans. (Courtesy of Hywel Meredydd Davies)

Born on Christmas Day in 1766 near Llandysul, Ceredigion, he was the son of a shoemaker who died when Christmas was just nine years old. He was sent to live with his uncle, working as a farm labourer, but he was treated harshly. Evans managed to escape at the age of seventeen to work on other farms. He began associating with Revd David Davies, renowned Presbyterian minister, bard and school teacher, and was converted during the local revival meetings. Hungry to learn the word of the Lord, he taught himself to read and write, and gathered with other converts in a local barn to read the Bible by candlelight. His conversion aggrieved his previous troublemaking companions. They waylaid him one night, and the beating they dished out caused him to lose his eye.

As his involvement in the church grew, he became more attracted to the doctrines of the Baptists, and he joined the Baptist church at Aberduar, where he was baptised by Revd Timothy Thomas. He had dabbled with preaching in the Presbyterian church, but his conversion led him to inject increased fervour and imagination into his style. He was ordained in 1789 and was sent to the Llŷn Peninsula, at that time the home of just a single small Baptist chapel, called Salem, to tour around the district preaching. During his three years there he not only more than doubled the congregation of Salem, but also inspired the establishment of other chapels. There, too, he met and married Catherine Jones.

In 1792, on his birthday of Christmas Day, he and Catherine set off to Anglesey at the invitation of the Baptists on the island, and settled into his base at Capel Cildwrn, near Llangefni. His task, for which he was paid £17 per year, was to reinvigorate the Baptist congregations scattered around the island in ten chapels.

Christmas Evans preaching. (From *Sermons of Christmas Evans*, by Joseph Cross, 1857)

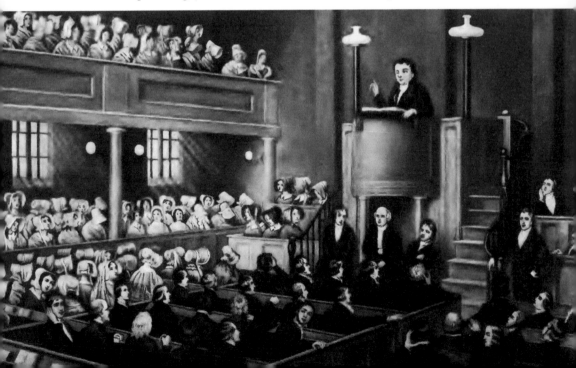

His powerful preaching style and determined drive rapidly drew more converts and led to the doubling of the number of chapels. During this time he often travelled throughout Wales, raising money for the creation of new chapels on Anglesey. He would preach along the way, greatly inspiring the crowds and increasing his reputation throughout the country.

After three decades on the island, his wife Catherine died in 1823. This, combined with his failing eyesight and the increasing desire of the Anglesey chapels to become more independent from his overall control, led him to leave Anglesey to take over the chapel at Tronyvelian, Caerphilly. During his two years there he again doubled the congregation, after which he moved to the Tabernacle chapel in Cardiff. In 1832 he moved back north to Caernarfon. He died in 1838 while on a preaching tour to Swansea.

A flavour of Evans' preaching style can be found in his account of journeying to Machynlleth, at a time he was struggling with his spirituality:

As I climbed up towards Cader Idris, I felt it my duty to pray; though my heart was hard enough and my spirit worldly. After I had commenced praying in the name of Jesus Christ, I could soon feel as if my shackles were falling off, and as if the mountains of snow and ice were quickly melting away. This engendered a hope in my mind for the promise of the Holy Ghost. I felt as if my whole spirit were liberating itself from some great bondage, and as if it were rising up from the grave of a hard winter. My tears profusely flowed, and I was compelled to cry out aloud, and pray for the gracious visitations of God, for the joy of His salvation, and for the divine presence once more in the churches of Anglesey that were under my care.

Capel Cildwrn, Llangefni.

Fairs and Markets

In these days of high streets, supermarkets and online shopping, we often forget how our ancestors shopped. Anglesey in particular had a mainly agricultural economy, and regular fairs and markets provided an outlet for farmers to sell their produce and livestock, and for other locally produced goods such as cloth and leather to be sold. They were also the places where drovers from England came to buy cattle to take back to the big cities via the old drovers' roads through the mountains.

In the early medieval days Llanfaes (near present-day Beaumaris) was the main commercial centre of the island, and is known to have had a fair in the thirteenth century. After Edward I's conquest of North Wales the burgesses of Llanfaes were evicted to Rhosyr (renamed Newborough) and Beaumaris Castle and town were

Fair day in Llangefni, early twentieth century.

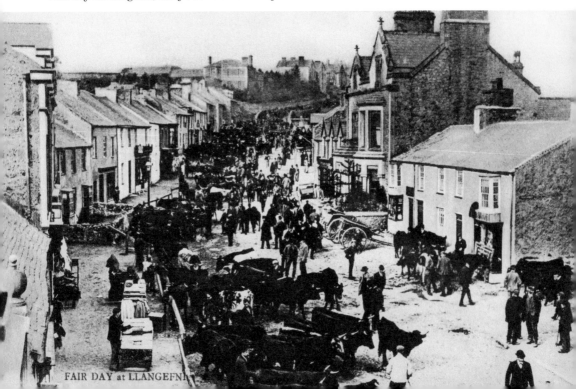

FAIR DAY at LLANGEFNI

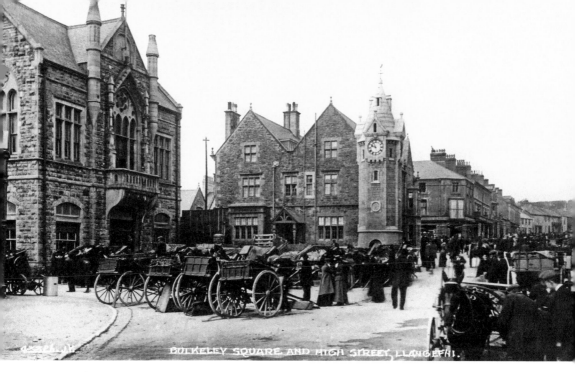

Llangefni market, around 1904.

built as the new commercial centre. Markets were set up in both towns, and by the fourteenth century markets had been instituted in Aberffraw and Llannerch-y-medd. A large market was also in existence in Caernarfon, and residents of south Anglesey regularly went via the ferry across the Menai.

By 1683 another regular fair had been established in Porthaethwy (Menai Bridge), but Llannerch-y-medd emerged as the biggest market town, with weekly markets plus six special fairs annually. By the next century fairs and markets were also being held in Amlwch, Llanfechell, Holyhead, Pentraeth, Llangefni and Bodedern.

Into the nineteenth century more fairs were held in towns like Gwalchmai and Llanddeusant, but Llannerch-y-medd was still the prominent one. However, through the century the growth in importance of Llangefni, as a result of increasing traffic on the post road going to Holyhead, meant that by 1870 it had equalled Llannerch-y-medd, with fourteen fairs annually each. By the turn of the century Llangefni was the preeminent market town on the island, as well as the county capital. Llannerch-y-medd ceased to hold markets and fairs by the end of the First World War.

The photos in this chapter show typical fair and market days in the early twentieth century, with the streets teaming with livestock and carts loaded with goods lined up with customers gathered around. Although most villages and towns lost their fairs and markets many years ago, the market in Llangefni has continued through the years, today still being held each Thursday and Saturday. Greengrocers and butchers sell their produce alongside stands of clothing, jewellery, tools and other household goods. A newer development, the Anglesey Farmer's Market, has been held in Menai Bridge every three weeks for the past decade or two, highlighting the diversity of foods produced on the island, including jams and preserves, cheeses, bread, eggs

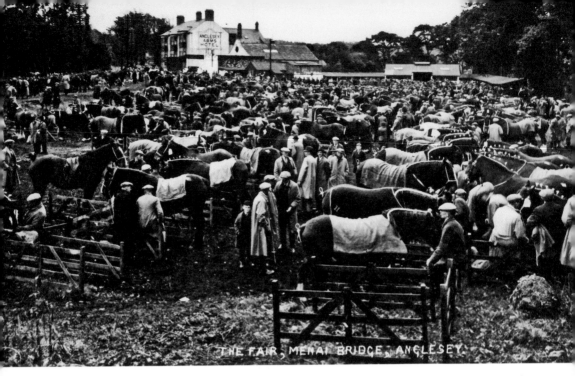

The annual horse fair in Menai Bridge, on the site now occupied by Waitrose. (Courtesy of Menai Heritage and John Cowell)

and meat. The annual fair tradition also continues in Menai Bridge, with the streets filled with stalls, fair rides and other amusements each October. More recently, Menai Bridge has been the home of an annual food festival, with street food stands lining the streets. The food festival idea has spread in the past couple of years and they are now held all over the island as well as across North Wales.

Llangefni weekly market.

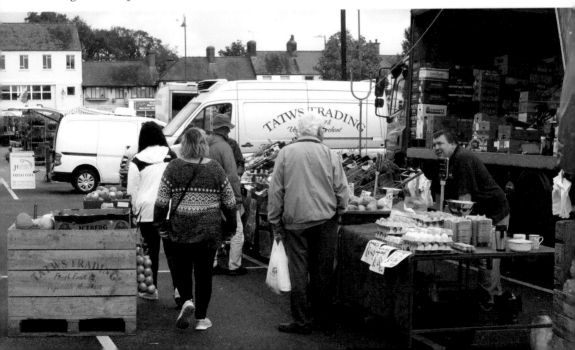

G

Geology

Every year geology students from around the UK descend on Anglesey. Why? Anglesey is a geologist's heaven, with a wide range of often complex rock formations, formed from more than 100 rock types over 1,800 million years from the Precambrian to the Carboniferous. This is topped off with some excellent displays of the effects of the late Ice Age glaciers.

The variety of rocks on the island is due to the varying geological processes it has been subject to through the ages. Because of plate tectonics (where different chunks

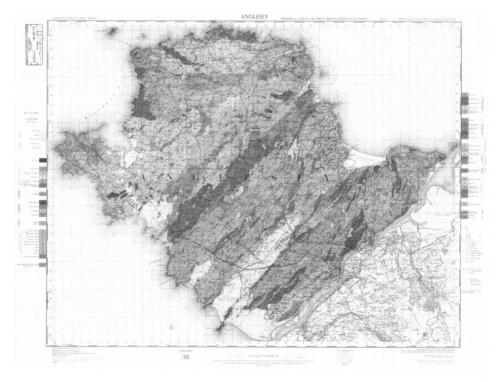

Geological map of Anglesey, based on Edward Greenly's work. (Contains British Geological Survey materials © UKRI 1967/Open Government Licence)

of the earth's crust are shifted around when magma from within the earth rises up to form new crust), what we now call Anglesey has migrated across the globe. At the time when the earliest rocks on the island were formed, around 800 million years ago, it was at the centre of Gondwanaland, a super continent in the southern hemisphere formed of what would later become Antarctica, Africa, India, Australia and South America. As these different plates began their migration to their current positions, Anglesey was able to start moving north. By around 390 million years ago, the chunk of crust containing Anglesey and the rest of southern Britain had collided with a separate chunk further north that contained Scotland.

As the two together moved to their current location the pressures they endured caused mountains to rise and cracks called fault zones to form (such as the one that is today the Menai Strait). Sea level rose and fell, and climate changed as the chunk of crust crossed the equator. New rocks formed as a result. When under the warm tropical seas, limestones were created from the calcium-rich shells of minute marine creatures. These limestones were used by man to build structures such as the Menai Strait bridges. At other times Anglesey stood above the waves, with sandstones and shales being created from river and lake deposits.

The flat horizontal layers of rock produced by these sediments were often later warped and folded by the intense pressures, creating dramatic structures such as those seen in the cliffs at South Stack. Rocks that had formed millions of years

Cliffs at South Stack, showing folding of rock layers on either side of the bridge.

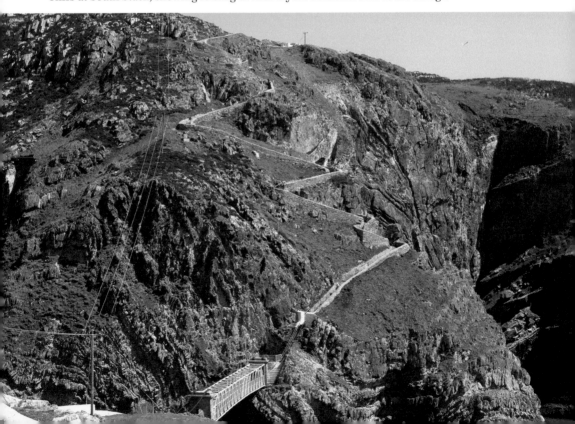

previously, then later buried deep within the crust, were brought to the surface again, metamorphosed into new rock types. Finally, the great ice sheets (over 1 km thick) of the last ice age 25,000 years ago stripped away some of the surface rock, but left behind rocky debris carried by the ice from as far away as Scotland, Ireland and the Lake District.

Our knowledge of the geology of Anglesey owes much to Edward Greenly. For twenty-five years he surveyed the rocks of the island, with his beloved wife and scientific collaborator Annie Barnard Greenly by his side. In 1919 he published the results in the two-volume work *The Geology of Anglesey*, followed by a geological map in 1920.

As he surveyed the rocks of Anglesey, he also added to the general geological knowledge by discussing unusual and distinct rock types. In particular, he described and named the rock type mélange. This is a jumble of a variety of different types of rock, in chunks of various sizes all fused together. It is formed as a result of plate tectonic movements, where different rock types grind against each other as one plate is forced under another. He also described spilitic lavas, also known as pillow lavas. These were formed by undersea volcanoes, where lava arising from the earth's interior erupted into cold seawater, causing it to solidify into piles of pillow-shaped rock. Often these pillow lavas were drawn back deep down into the crust, where they

Pillow lavas at Llanddwyn.

were subject to great pressure and heat. This caused them to metamorphose into blueschist, another unusual rock type for which Anglesey is world renowned.

The geology of Anglesey is so special that in 2010 it was named as one of a global network of Geoparks, under the auspices of UNESCO (who also oversee selection and protection of World Heritage Sites). The formation of the Anglesey Geopark was spearheaded by Geomôn, who are very active in educating the public about the geology of the island. They have erected a number of information boards at sites of geological interest, and have a visitor centre in Amlwch Port.

Geological 'clock' erected by Geomôn at Amlwch port, showing the major rock types on Anglesey, arranged by their age through time.

Houses

Since the Second World War the growing population of Anglesey and the desire for people to have larger and more comfortable homes has led to a boom in housebuilding. Our towns and villages have sprouted estates of houses built with materials easily transported from around the world. However, the island is also rich in examples of earlier styles of dwellings, built with local materials, and often by the occupier's own hands, with help from neighbours.

The earliest inhabitants of Anglesey in the Mesolithic were nomadic hunter-gatherers. They would have probably built some sort of shelter of vegetation, animal skins and mud, but as these would have rotted away long ago nothing is known of them. As the people settled down to farm in the Neolithic there have been some hints of their dwellings, in the form of post holes showing where upright timbers once

Recreated round house near Melin Llynnon windmill.

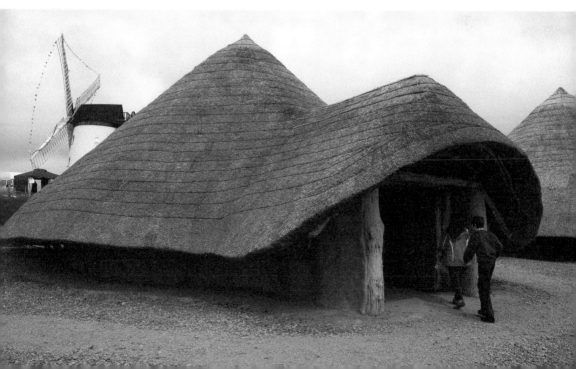

stood, alongside finds of stone tools, hearths and middens full of domestic refuse, but these are rare.

It was only when structures of stone were built that we can more readily begin to see how they lived. Scattered around Anglesey are a number of remains of circular walls. These hut circles are often marked as *Cytiau'r Gwyddelod* (Irishmen's Huts) on old Ordnance Survey maps, although there is no evidence that they have anything to do with the Irish, who did invade Anglesey much later in the Viking era. These circles usually occurred in groups, often on hilltops with defensive walls as hill forts. They were the bases of round houses, with large timbers forming a conical structure that was then covered with thatch. Excavations of some of these hut circles have revealed stone tools, pottery, animal bones and even coins. These have helped to identify these as dating from the early Iron Age (800–500 BC) through the Roman era of the second to fourth century AD.

Towards the end of this period houses began to be built with rectangular walls rather than circular, and some sites, such as Din Lligwy, have both types within the same settlement. Rectangular houses have the advantage of allowing them to be built much larger. One prominent example of this on Anglesey is Llys Rhosyr –

Llys Llywelyn, a recreation of the Llys Rhosyr royal court, at St Fagans National Museum of History, near Cardiff.

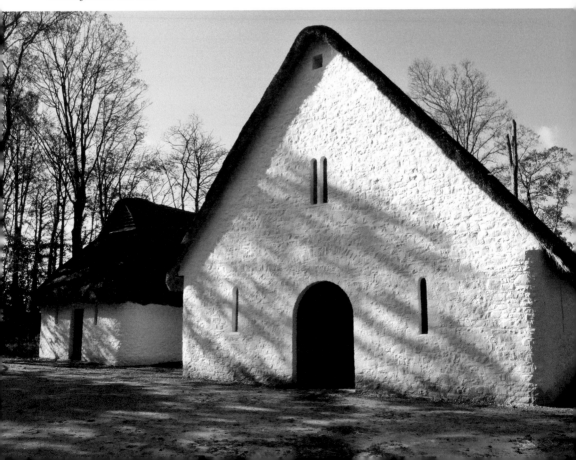

one of the royal courts of the princes of Gwynedd. Excavated in 1992–96, this site near Newborough contains the foundations of several buildings that served various functions in the thirteenth century, including the large main hall, built to impress visitors, and a separate accommodation building, with a passageway between the two. The foundations of these buildings can be visited and viewed at the site, but the St Fagans National Museum of History near Cardiff has recreated the hall and one other building as they are thought to have originally appeared, with spectacular effect.

Through the centuries increasing prosperity and advancing building technologies produced grander and more comfortable houses. These retained a great hall of some sort, but with a second floor and additional wings to accommodate living space, storage and other functions. An excellent example of this is the fifteenth-century Hafoty house in Llansadwrn, one of the oldest houses still standing on the island. The H-shaped house has a grand hall in the middle, with massive roof beams and a large fireplace, and two-storey accommodation wings on either side. Into the sixteenth and seventeenth centuries numerous gentry houses were built around the island, including the ancestral home of Owen Tudor and the royal Tudor dynasty, Plas Penmynydd. Many of these houses still stand in a similar floorplan as when they were built. Others have had extra wings added, including one of the largest mansions on Anglesey, Plas Newydd, which has at its core a sixteenth-century hall house, but has been modified through the centuries beyond all recognition.

Hafoty medieval house, Llansadwrn.

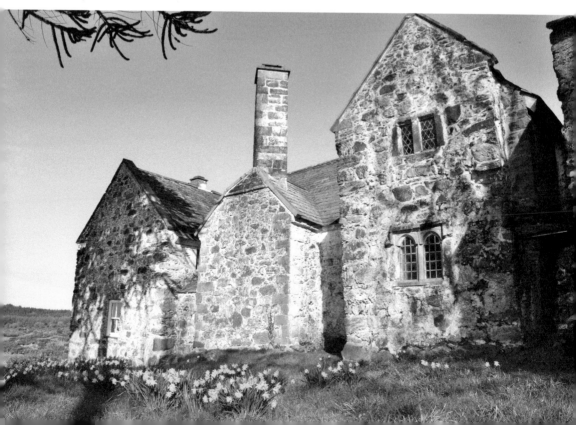

These houses were built by and for the rich landowners of the island. The majority of the population lived in much rougher conditions. In the twelfth century Gerald of Wales wrote that the common people 'neither inhabit towns, villages, nor castles, but lead a solitary life in the woods, on the borders of which they do not erect sumptuous palaces, nor lofty stone buildings, but content themselves with small huts made of the boughs of trees twisted together, constructed with little labour and expense'. In later ages more permanent structures of stone and mud were built, but they would have been small and not long lived. Better dressing of the stone, and the use of lime mortar later produced cottages that were more sturdy.

Near Church Bay stands the restored cottage Swtan. The original cottage dates from the sixteenth century, but numerous extensions and outbuildings turned it into the centre of a substantial smallholding. It was restored in the 1990s and is now open to the public to show what life was like for the average rural dweller before the modernisations of the twentieth century.

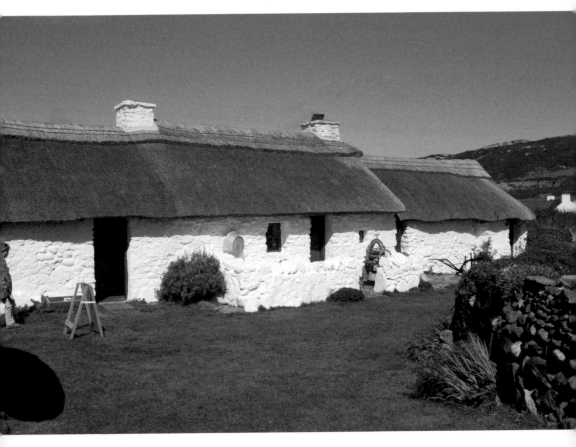

Swtan restored cottage.

Industry

Anglesey is known as *Môn Mam Cymru*, or Mona, Mother of Wales. Its fertile fields and superb grain output also led it to be considered the breadbasket of Wales. But, despite its agricultural pre-eminence, it has also had a number of prominent industries through the ages.

The earliest industries focused on harvesting other natural resources. Copper mining (as described in Amlwch and the Copper Kingdom, see page 5) was occurring as early as the Bronze Age, and at its height Parys Mountain employed 1,200 miners.

Production of building materials was also important, with small local quarries dotting the landscape. These were mostly used for local needs, building cottages and houses in the surrounding area. But some quarries with excellent quality limestone

Flagstaff quarry and works buildings at Penmon.

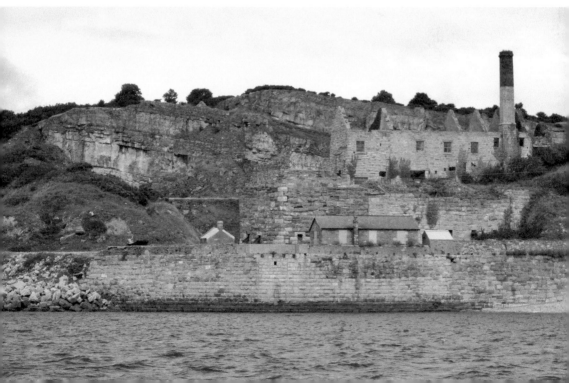

produced stone for major buildings further away. The quarries at Penmon supplied limestone not only for the nearby Beaumaris Castle, but also for Caernarfon Castle and the two bridges over the strait. It even shipped out stone for buildings around Britain, including the Birmingham Town Hall. Similar limestone was quarried all along the coast to Red Wharf Bay and inland near Moelfre.

The numerous windmills and watermills on the island (see Windmills, page 83) required large circular stones with a rough texture to grind the grain. A type of stone called millstone grit (which is often interspersed with beds of limestone) was highly prized for milling, and outcrops of this occur near Benllech. Millstones produced here were exported as far as Dublin and the Baltic states. Evidence of the millstone quarrying can still be seen today; in the centre of the Cors Goch nature reserve walkers can see a millstone that was almost completely carved out of the underlying rock, but then abandoned many decades ago when quarrying ceased.

Other materials were quarried around the island as well. In the late nineteenth and early twentieth centuries there was increasing demand for fire bricks to line the steel-making furnaces of the industrial age. One of the major components, quartzite, is abundant along the north Anglesey coast, so many quarries were opened and brickworks were built nearby. The ruins of the one at Porth Wen can still be seen (see the photo in the Quays section, page 64). Also on the north coast was a small quarry producing excellent quality kaolin (or china clay), which supplied a porcelain

Porcelain factory at Porth Llanlleiana.

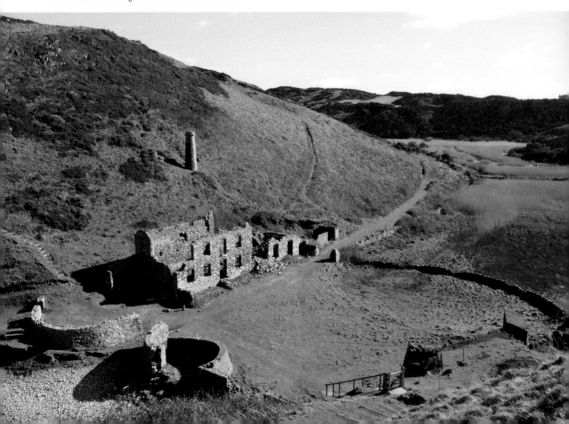

factory at Porth Llanlleiana. This processed the clay and turned it into finished porcelain objects until it was closed after a fire in 1920.

Although dwarfed by the huge coal mining industry of South Wales, Anglesey does have a coal field that was commercially mined. Lying in the valley along the Afon Cefni between Llangefni and Malltraeth, the coal has been mined here since at least 1441, when a lease to mine for coal was granted to John Pykemere and Hywel ap Llywelyn ap Dafydd ab Ieuan. Much of this area was under water or marshy at the time, but the draining of the valley when the Malltraeth Cob was built in the 1790s led to many more mines opening. By 1851 there were 140 coal miners, but numbers dwindled and the mines were all closed by the end of the nineteenth century. The ruins of a series of buildings related to one of the mines still stand near Pentre Berw.

Natural ingredients formed the basis of other industries. In the sixteenth century, after centuries of the wind-blown sand dunes of Newborough burying nearby houses and fields, the government of Elizabeth I ordered that marram grass be planted to stabilize the dunes. This led to a thriving cottage industry where the long, strong leaves of the grass were woven into mats, ropes and baskets.

The abundant cattle on the island led to another industry where their leather was used to make shoes. These were often made locally, but the village of Llannerch-y-medd became a centre of boot making, with up to 250 cobblers working there in 1833 – initially to supply miners at nearby Parys Mountain. The rise of large shoe factories in England in the 1870s led to decline of the industry.

Wylfa nuclear power plant in the distance, with an older form of power generation, Felin Cafnan, a ninetenth-century watermill, on the right.

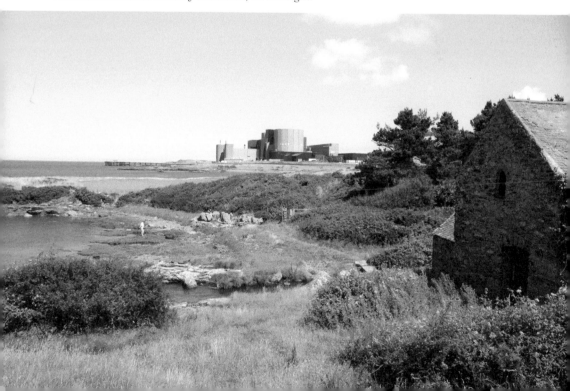

By the twentieth century all the above industries had dwindled or disappeared. These were mostly replaced by small-scale manufacturing and the growth of retail and other services. Some larger manufacturing centres developed during and after the Second World War, such as the Sanders Roe plant near Beaumaris, first built to refurbish flying boats for use during the war, but later making bodies for buses. Other large industries begun post war were a bromine extraction plant and an oil terminal near Amlwch.

One limitation to industry on Anglesey was available power, but the construction of the Wylfa nuclear power plant in the 1960s changed that. It allowed particularly energy-hungry aluminium smelting to be set up on the island with the Anglesey Aluminium plant near Holyhead. Between the two they provided hundreds of jobs, but the planned winding down of the nuclear plant led to the closure of the aluminium plant in 2009, with Wylfa ceasing power production in 2015.

As the old industries faded away attention turned to attracting new ventures. Anglesey Council has been following an Energy Island strategy to develop renewable energy sources such as solar farms, wind turbines and tidal power schemes offshore from Holyhead. The old Anglesey Aluminium site is being redeveloped into an ecopark, where a plant burning biomass will provide electricity, with the excess heat and carbon dioxide being used to aid in growing crops and fish in environmentally controlled buildings. And the recently completed Menai Science Park aims to provide space and support for new knowledge-based companies.

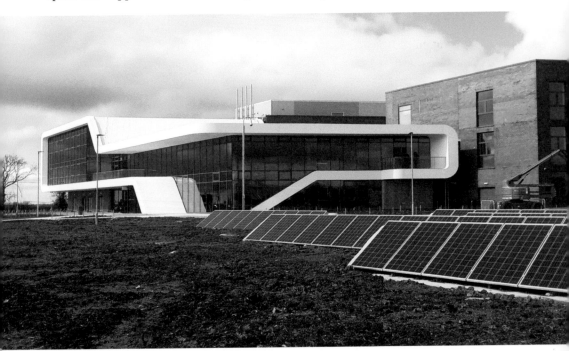

M-SParc, the home of the Menai Science Park near Gaerwen.

J

Jets and Propellers

Soon after the Wright brothers' invention of the first successful airplane in 1903, pioneering aviators began to look at Anglesey for the site of setting new records. Louis Bleriot had made the first powered flight across English Channel in 1909, and others wanting to replicate his fame were soon eyeing up the crossing of the Irish Sea.

The well-known actor Robert Loraine was inspired to learn to fly after witnessing Bleriot taking off on his famous flight. After several months of training at Bleriot's school in France, Loraine was determined to be the first to fly across the Irish Sea. In August 1910 he set off from Blackpool to Holyhead, from where he would start his pioneering journey. However, Loraine had the unfortunate distinction of being the first to crash an airplane on Anglesey. After getting lost in the haze over the sea north of Anglesey, he ran out of fuel and managed to land in a field near Llanfairynghornwy. After refuelling, his attempt to take off to finish the journey to Holyhead failed, with the crash causing major damage to the airplane. After several weeks of repairs he was finally able to take off towards Dublin on 11 September, but mechanical failure caused the plane to ditch in the sea just 200 yards short of the Irish coast. Loraine survived and swam to the coast.

In early 1912 Damer Leslie Allen made an attempt to fly from Holyhead to Dublin, but disappeared and was presumed dead. A week later, on 26 April 1912, Vivian Hewitt successfully flew from Anglesey to Ireland, landing in Phoenix Park in Dublin, to great acclaim. However, unknown to him, just four days earlier Denys Corbett Wilson had flown from Pembrokeshire to Co. Wexford, making him the first to cross the Irish Sea. Anglesey remained close to Hewitt's heart and he later returned to the island, buying Bryn Aber, a house overlooking Cemlyn Bay. A keen ornithologist, he established a nature reserve there, now owned by the North Wales Wildlife Trust.

Anglesey was also the site of some early developments of airplane technology. In 1911 Bangor University professor George Hartley Bryan published an important book about the physics of aviation and aeroplanes, formulating equations still used today. He was assisted in his research by student William Ellis Williams. Williams took the theory further to reality and erected a hanger near the foreshore of Red Wharf Bay at Llanddona, where he built a test airplane named *Bamboo Bird*. After much difficulty,

and the purchase of a more powerful engine, Williams managed to make a successful flight, taking off from the Red Wharf Bay sands in 1911.

With the coming of the First World War the use of airplanes took on a much more serious role. German U-boats prowled the Irish Sea, and observations from the air became important in battling them. The Royal Navy Air Station Llangefni was founded in 1915 as the base for airships. These blimps, large bags filled with lighter-than-air gas with a small gondola suspended below, were slow moving and were able to escort convoys, scout for submarines and even drop bombs. At the end of the war one of the pilots, Tommy Elmhirst, celebrated the Armistice by flying his airship underneath the Menai Suspension Bridge.

The beginning of the Second World War in 1939 brought a real threat of invasion by Germany. Coastal defences were built all around Britain, including many airfields. In 1940 work started on Anglesey's first airfield on land requisitioned from the Meyrick estate of Bodorgan. Consisting of a grass runway, hangers, accommodation huts and other office buildings, the site was originally called RAF Aberffraw, but later renamed RAF Bodorgan. The initial purpose for the airfield was as the base for an Anti-Aircraft

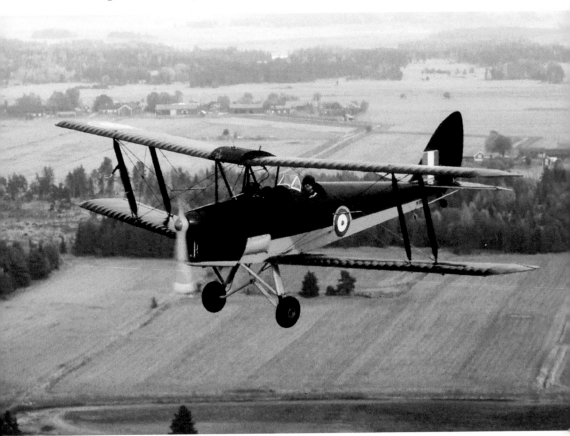

De Havilland DH 82A Tiger Moth. (Courtesy of Towpilot under Creative Commons)

Co-operation Unit. It was the home of a number of radio-controlled De Havilland Tiger Moth biplanes, dubbed 'Queen Bees'. They towed targets in the air for practice by the anti-aircraft gunners based at the nearby Ty-Croes Artillery Range (now the site of the Anglesey Race Circuit). Later in the war it was used as a Satellite Landing Ground, a place where aircraft could be stored, hidden in wooded areas, to reduce the likelihood of attack by the Luftwaffe. The airfield closed in 1945 and reverted to agricultural use, although many of the old buildings are still standing.

The Bodorgan airfield was quickly followed by another one near Rhosneigr. RAF Valley hosted fighter squadrons to provide defence of shipping in the Irish Sea and industrial sites in northwest England (which the German bombers approached over Wales). It initially had Hawker Hurricane and Bristol Beaufighter fighter planes, as well as the occasional Spitfire. Later in the war the airfield was enlarged to act as a transit terminal, providing an initial landing site for American B17 and B24 bombers after their cross-Atlantic flights. Its role as an RAF base has continued since the war, primarily as an Advanced Flying School. The student pilots currently fly BAE Hawk T2 jets, which are regularly seen over Anglesey. Until recently RAF Valley also was

Site of the former RAF Bodorgan airbase.

the home to the Sea King helicopters of the RAF Search and Rescue service, but these have now been replaced by Bristow helicopters flown out of Caernarfon airport. In 2007 civilian flights also began flying out of Valley, with daily services to Cardiff. In 2019 RAF Valley also became the home of basic fast jet training, using prop-driven Beechcraft Texan T MK1 airplanes.

The First World War airship station near Llangefni was turned into an isolation hospital (for patients with contagious diseases) after 1918, but in 1942 it was transformed into RAF Mona. Its primary purpose was as a training base, providing initial flight training as well as hosting the No. 3 Air Gunnery School. After the war it continued to be used for training in conjunction with RAF Valley, in particular for circuit training (repeated takeoffs and landings) and as a relief landing ground. In the 1970s it was opened to civilian pilots and became home of the Mona Flying Club.

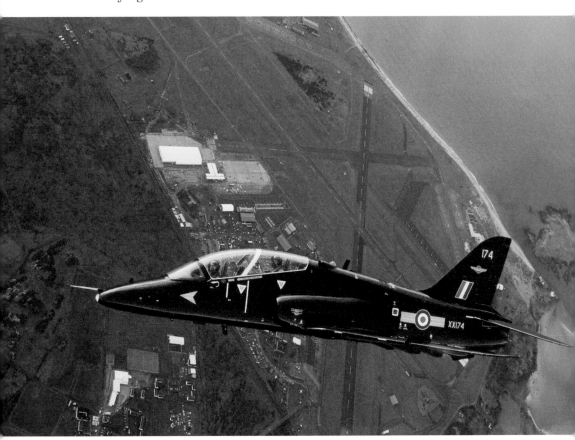

RAF Hawk T1 jet flying over RAF Valley. (Courtesy of Cpl Paul Oldfield/MOD)

K

(Sir) Kyffin Williams

The dramatic landscapes and characterful buildings of Anglesey have been a draw for artists for many years. But no one captured Anglesey and nearby Snowdonia better than Kyffin Williams. His depictions of the rugged landscapes and rural life of Wales have made him one of the most famous Welsh artists of the twentieth century.

Born John Kyffin Williams in Llangefni on 9 May 1918, he comes from an old landed Anglesey family. He was proud of and fascinated by his ancestry, and the first two chapters of his autobiography *Across the Straits* delve into the family stories. He traced his direct male line back to Wmffre ap William ap John ap Rhys, born in Llansadwrn in 1661. He was a blacksmith, and the story goes that he became rich after a horse he was shoeing, which had been tied to a dead tree stump, pulled it up to reveal a golden bowl, likely to be Celtic treasure. He used the proceeds of selling the gold to buy the farm of Cefn Coch, which did well and made Humphrey Williams (as he became known after anglicising his name) a rich man. His son Owen added Treffos and other lands to the property portfolio. Owen's two sons John and Thomas

Self-portrait of Kyffin Williams from his book of lithographs, *Cutting Images*. (Courtesy of Gwasg Gregynog).

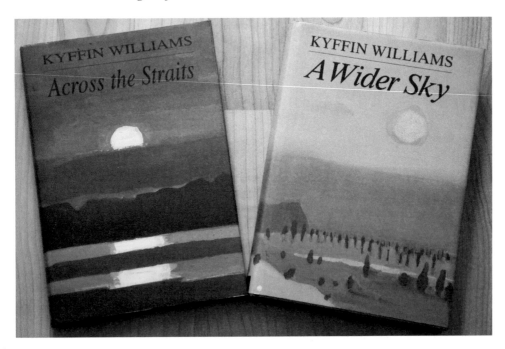

Kyffin Williams' memoirs, with covers designed by the artist.

also prospered; Thomas became involved in the development of the Parys Mountain copper mines and became one of Wales' richest men, while John (Kyffin's great-great-grandfather) expanded his property holdings through his royal connections as the chaplain to Princess Augusta of Wales (mother of George III).

Kyffin's father Henry was the manager of the bank in Llangefni that had been founded by his great-uncle Thomas Williams. His banking career meant the family moved often, with stints in Chirk and Pentrefelin (near Criccieth), but always returning to Anglesey. Just before his seventh birthday Kyffin was sent to a boarding school at Trearddur Bay. There he often walked the coast and became fascinated by the stormy seascapes that later featured prominently in his paintings. At thirteen he entered Shrewsbury School where, despite having a difficult and lonely time, he excelled in his exams.

He had always dreamed of being a cavalry officer, and after leaving Shrewsbury he applied for an army commission. However, while waiting for his commission he suffered a grand mal epilepsy attack. He soon received his commission with the Royal Welch Fusiliers and took well to army life, enjoying commanding a platoon. But further epileptic attacks led him to being assessed at a military hospital where the doctor advised, 'Williams, as you are in fact abnormal, I think it would be a good idea if you took up art.' Despite his protestations, he never returned to the military.

Kyffin had shown interest in drawing from a young age, so fate seemed to have conspired to push him in that direction. Once he got over the disappointment of leaving the army he applied to Slade School of Fine Art in London. He was accepted

and in 1941 began studying under Randolph Schwabe and Allan Gwynne-Jones. After graduating in 1944 he secured a place teaching art at Highgate School in London, where he stayed for twenty-nine years.

His illness meant he often needed the respite of holidays, and he regularly returned to Wales to visit family and to draw and paint. He also travelled widely on the Continent, and in 1968 he won a scholarship to go to Patagonia and paint Argentinian landscapes and the Welsh community there. These travels are beautifully described in the second volume of his autobiography, *A Wider Sky*.

After his retirement he returned to Anglesey. His friends the Marquess of Anglesey and Lady Anglesey offered him a house at Pwllfanogl on their estate for his studio. Overlooking the Menai Strait and Snowdonia, and in the shadow of the Britannia Bridge, Kyffin spent the rest of his life there, painting the land he loved.

He was elected a member of the Royal Academy in 1974, was awarded an OBE in 1982, and was knighted in 1999. His legacy is preserved by the collections of his huge body of work in many public buildings throughout Wales. In particular, the dedicated Kyffin Williams Gallery in Oriel Ynys Môn, Llangefni, and the National Library of Wales in Aberystwyth hold and display large amounts of his work. Kyffin died in 2006 and is buried in the churchyard of Llanfairynghornwy, where his great-grandfather had been rector.

Below left: Statue of Kyffin Williams outside Oriel Môn, by sculptor David Williams-Ellis.

Below right: Kyffin Williams' gravestone at Llanfairynghornwy, designed by sculptor Ieuan Rees and made of Welsh slate.

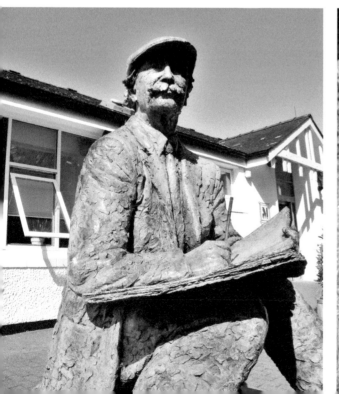
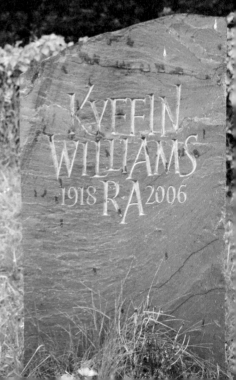

Lighthouses

Anglesey is an island with a very rocky coast, situated on the busy shipping lanes of the Irish Sea. As a result, its coast is dotted with lighthouses to warn mariners of hazards and provide navigation aids.

Although it has been suggested that the Roman watchtower on top of Holyhead Mountain may have had a light signal, the earliest lighthouse still in existence is on the Skerries. This group of rocky islets 3 km off the main Anglesey coast posed a danger to ships heading for Liverpool. In 1713 William Trench obtained a lease for the islands, and the following year he was given permission from Queen Anne to build and maintain a lighthouse, for which he could charge one penny per ton of the ships passing within sight of the light. The light was completed by 1716, but only after the tragic drowning of Trench's son Robert during the construction. Problems with collecting the fees at the destination ports, combined with the high maintenance costs, meant that Trench was in dire financial straits when he died in 1725. An Act of Parliament in 1730 allowed for changes to the collection procedures and the fees, so that later owners were able to maintain it properly. The lighthouse was rebuilt in 1759, and in 1804 the original coal brazier light was replaced by an oil lamp. It has been operated by Trinity House since 1841, and the current electric lamp, powered by solar panels, was automated in 1987.

By the mid-eighteenth century Point Lynas, on the north coast of Anglesey, had become a regular spot where pilot boats from Liverpool would meet incoming ships. In 1781 a pilot station was built here, with a house to provide accommodation. Lights were lit in the upper windows of the house to guide ships to the mooring places. In 1819 the Liverpool Docks company secured an Act of Parliament to build an improved lighthouse, but this wasn't completed until 1835. As it was being built on a hilltop on a headland with high cliffs, a tower wasn't needed, and the light is at ground level, with a lookout and telegraph room above. The Mersey Docks and Harbour Board continued operating it until 1973, when it was taken over by Trinity House. The building complex includes a castellated wall that encloses various keepers' cottages, which are now used as holiday accommodation.

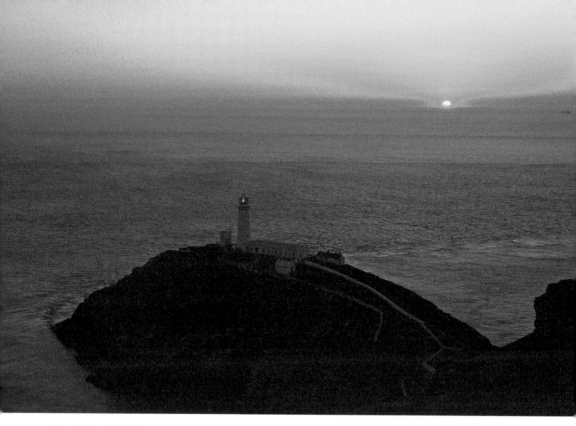

South Stack lighthouse.

There had long been calls to erect a lighthouse on South Stack, near Holyhead, ever since a petition was sent to Charles I in 1645. The Act of Union between Britain and Ireland in 1800 led to plans finally being approved, and in 1809 the lighthouse was completed. Its original light composed of twenty-one oil lamps has been upgraded several times since then, to the current small electric bulb, and various foghorns and lower level lights were added to provide signals in poor weather conditions. The 28-metre-high tower is one of the most popular tourist sites on Anglesey, as it stands in a dramatic location on Ynys Lawd, a small rocky island just off of Holy Island. Reaching it requires climbing 400 steps down a cliff face, then crossing a bridge.

The south-western mouth of the Menai Strait is overseen by Llanddwyn Island. To assist ships entering the strait to Caernarfon, Felinheli and Bangor a tower was built at the end of Llanddwyn to act as a navigational aid. Probably erected in the late eighteenth century, Tŵr Bach had no light and was just a visual reference marker. However, it was found to be too low to be easily seen by ships at sea, so another tower, Tŵr Mawr, was built on a higher point sometime between 1800 and 1823. It was fitted with a light, shining out of windows in a room added to the base of the tower, in 1846. In the 1970s a modern electrical lamp was mounted on the older Tŵr Bach and the Tŵr Mawr light was removed. Tŵr Mawr is today one of the most iconic images of Anglesey.

At the other end of the Menai Strait, the Trwyn-du lighthouse was built between Penmon Point and Puffin Island in 1835–38. The impetus for finally building this

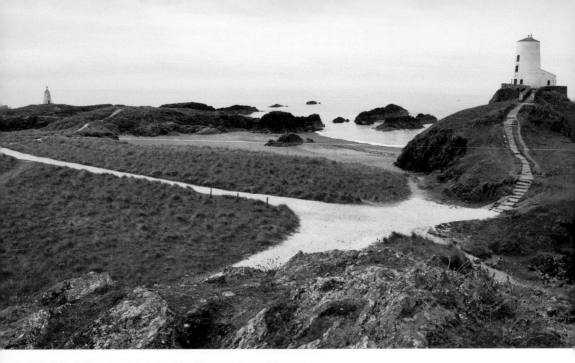

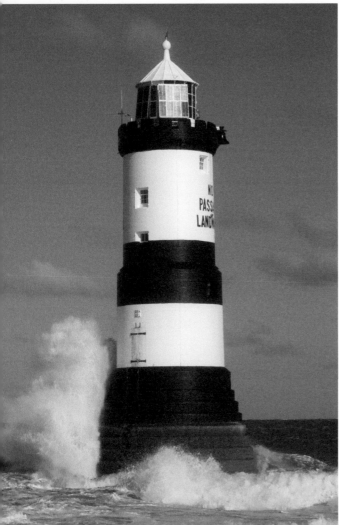

Above: Llanddwyn Island lighthouses, Tŵr Mawr on the right, and Tŵr Bach on the left.

Left: Trwyn-du lighthouse at Penmon.

lighthouse, which had been called for over many years by Liverpool shipmen, was the grounding and wreck of the Rothsay Castle nearby in 1831, with the loss of 130 lives. Unlike many earlier lighthouses, the designer James Walker gave this one a stepped base rather than straight sides. This reduced the damaging effect of the upsurge of huge waves at the base.

Beside the coastal lighthouses, Anglesey also boasts a number of harbour lights. As the main port for Ireland, the busy Holyhead harbour has two. On the Admiralty Pier, Salt Island, stands a lighthouse that was built in 1821 based on John Rennie's design as part of his upgrading of the ports of Holyhead and Dublin. An identical tower stands at Howth, in the north of Dublin Bay. The Salt Island tower replaced an earlier one shown in William Daniell's 1815 engraving, which itself had replaced an old thatch-roofed tower. This fell into disuse in the mid-eighteenth century after the pier was extended in the works that improved the harbour, including building the mile-long breakwater. The breakwater was punctuated by another lighthouse, square in plan rather than round like others on Anglesey. It was finished sometime before 1873 and is still operating, guiding the modern ferries and other ships into the harbour. Another square lighthouse and watchtower can be found at the harbour entrance to Amlwch port. The current tower, built in 1853, succeeded one built in 1817, and two previous lighthouses on this site.

Holyhead Breakwater lighthouse, with the Stena HSS *Explorer* passing on its way out of port.

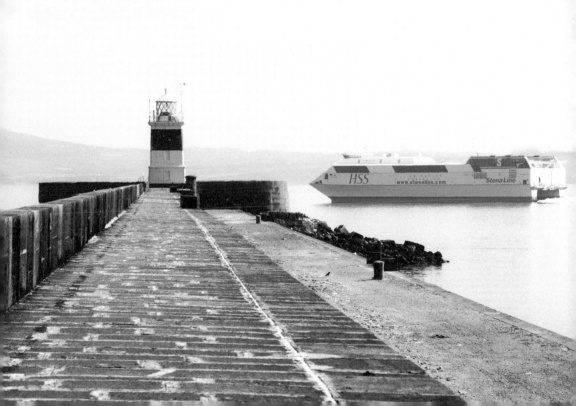

Morris Brothers

Other families mentioned in this book come from the wealthy landowning class. However, one of the most remarkable families on Anglesey came from a humble background, rising to become renowned scholars, musicians, naturalists and chroniclers of life in Enlightenment-era Wales. The Morris Brothers (also known as *Morrisiaid Môn*) were the sons of Morris Ap Rhisiart Morris, farmer, carpenter and cooper, and Margaret Owen. Lewis, Richard, William and John, along with their sister Margaret, were born in the first decade of the eighteenth century. In 1707 the family moved from Llanfihangel-Tre'r-Beirdd, near Mynydd Bodafon, to the farmstead Pentre Eiriannell, overlooking Dulas Bay.

The boys grew up practicing their father's crafts, and had little traditional schooling, but still developed a love of learning. In adulthood their careers went in different directions and took them to different places, but they very regularly wrote letters to each other. These hundreds of letters were transcribed and published in 1907 by John H. Davies and give us an insight into their lives and Welsh life and culture in general.

Lewis Morris was the eldest, and arguably the most famous. As a youth he was interested in natural philosophy and mathematics, as well as old Welsh poetry. He began his working adult life as a land surveyor, while still living at home with his

Lewis Morris.

parents, at one point doing work for the Meyrick family of Bodorgan estate. He was then appointed as customs officer for the ports at Beaumaris and Holyhead. During this time he pursued his interests in Welsh poetry, compiling a manuscript collection of ancient poems as well as composing his own, using the bardic name *Llewelyn Ddu o Fon*. He even purchased a printing press, intending to publish Welsh literature, but the business never flourished. He was patron of many Welsh writers, including the famous Anglesey poet Goronwy Owen. He also pursued music, using the carpentry skills learned from his father to build a harp.

Through his connections with the Meyricks, he was appointed in 1737 by the Admiralty to survey the coast of Wales and its ports. The resulting maps were eventually published in 1748. These were a popular and valuable tool for mariners of the day, as well as a good source of information for modern historians. These maps were updated and republished in 1801 by his son, William.

In 1744 he was commissioned to survey the manor of Perfedd in north Cardiganshire, and two years later was appointed deputy steward of the crown manors in Cardiganshire. During this time extensive deposits of lead were found in the county, and many very profitable lead mines were developed. However, as the crown representative, Lewis Morris was involved in many legal wranglings between his employers and the local landowners, who even at one point imprisoned him while they took over the mines.

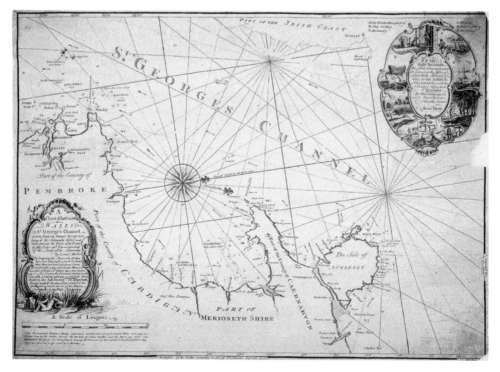

Lewis Morris' chart of the coast of Wales and St George's Channel. (National Library of Wales)

Later in life he became more interested in Welsh history and antiquities, and began work on a dictionary of Celtic mythology, history and geography. Although completed in 1757, it was not published in his lifetime. The manuscript was handed down through the family and eventually published with the title *Celtic Remains* in 1878. Lewis died in 1765, having married twice and had thirteen children.

The second Morris brother was Richard, born in 1703. He left for London around 1721, never to return to Anglesey. Little is known of his early life there, but he was working as a clerk and accountant. He seems to have often been in financial straits, freely lending money to the detriment of himself and his family. This came to a head in 1734 when, being the surety for a man who went bankrupt, he had much of his property confiscated and spent twelve months in Fleet Prison.

Although he had physically left Wales far behind, he was still immersed in Welsh culture and language. He acted as an interpreter in the law courts and was involved in the publication of Welsh books, including the Welsh Bible and a translation of the Book of Common Prayer. He was also at the centre of Welsh society in London, and in 1751 founded the Cymmrodorion Society with the support of his brother Lewis. It was established as a social, cultural, literary and philanthropic institution, and Richard was its first president, remaining in office until his death in 1779. One of the society's main aims was the support of the Welsh Charity School in London. On his death Richard left his books and manuscripts to the school in the hopes that it would

Memorial to the Morris Brothers, near their childhood home of Pentre Eiriannell.

form the nucleus of a national library for Wales, but they were eventually transferred to the British Museum in the 1840s.

Little is known of the youngest brother, John. Born in 1706, he is known to have lived with his brother Richard in London for a while in 1735, when both were in poor financial situations. In his few letters to survive, written in 1739–40, he expresses wanderlust, aiming to sail to India as well as Guinea, the West Indies and North America. In 1741 he was master's mate on the warship *Torbay* when he was killed during an expedition against the Spanish at Cartagena, Colombia.

The only one of the four brothers to remain on Anglesey his whole life (with the exception of a stint in Liverpool as a youth) was William. Born in 1705, he was apprenticed to an apothecary in Llannerch-y-medd. He was later appointed collector of customs at Holyhead in 1737, where he settled for the rest of his life. His duties were varied; in 1741 he wrote to Richard that he was 'deputy customer, collector, deputy comptroller, comptroller of the coal duties, deputy searcher, coast waiter and searcher, water bailiff, deputy vice-admiral, collector of the Skerry lights, surgeon, florist and botanist to the Garrison of Holyhead!'

Although he had the same interests in Welsh literature, antiquities and music as his brothers, he was also an excellent and keen naturalist, probably influenced by his mother's interest in medicinal herbs. His studies of the plants of Anglesey, laid down in the manuscript entitled *A Collection of Plants Gathered in Anglesey*, was used extensively by Revd Hugh Davies in his pioneering *Welsh Botanology*. He also developed an extensive garden at his house near the Roman fort in Holyhead. Always looking for new plants for his garden, William cultivated connections with sea captains sailing in and out of Holyhead, imploring them to bring back seeds of new and unusual plants.

Of all the letters preserved in the Davies publication, over two-thirds of them were written by William. Being the only brother to remain on Anglesey, William's letters provide a wealth of information about the eighteenth-century social history of the island, widely used by historians today.

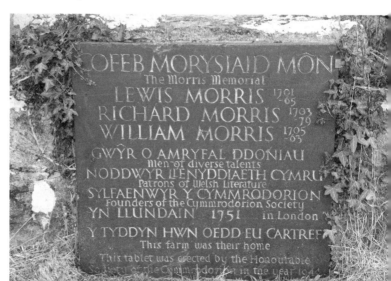

Plaque on the steps leading to the Morris Brothers memorial.

Nature Reserves

Anglesey is a wildlife watcher's delight. Encircled by a 200-km coast path, covering majestic cliffs and wide sandy bays, much of the coast has been declared an Area of Outstanding Natural Beauty. In the interior many marshes, heaths and woodlands have been given protection as National Nature Reserves, Local Nature Reserves or Sites of Special Scientific Interest.

One of the most spectacular reserves is South Stack, near Holyhead. The protected grasslands and heath, home to many rare plants, insects and birds, ends abruptly at the 131-metre-high cliffs. In the spring and summer the cliffs are home to a raucous community of thousands of nesting razorbills and guillemots, with puffins popping out of their burrows in the grassy areas. Choughs and the occasional peregrine falcon swirl overhead.

Guillemots nesting on the cliffs at South Stack.

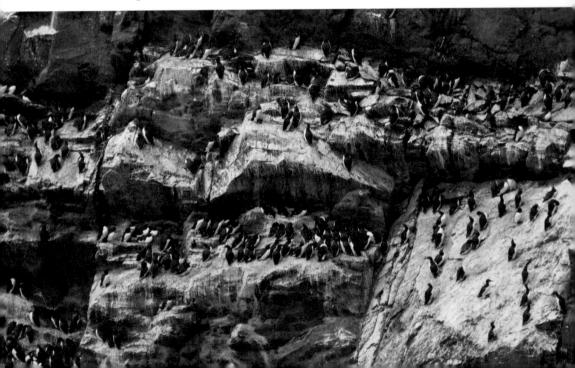

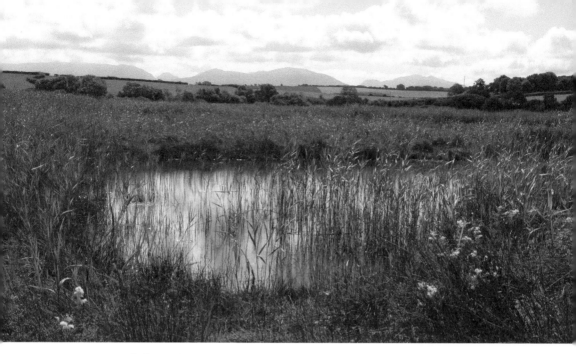

Fens at Cors Bodeilio, with Snowdonia in the distance.

Four sites on Anglesey have been declared National Nature Reserves (NNR), important sites protected under the National Parks and Access to the Countryside Act 1949. Three are fens (lime-rich wetlands) near Red Wharf Bay: Cors Bodeilio, Cors Erddreiniog and Cors Goch. The paths and boardwalks through these reserves take you past stands of reeds, sedges and rushes, interspersed with insectivorous plants and rare orchids. Dragonflies and damselflies hover over pools populated with frogs, great crested newts and medicinal leeches, while reed buntings, warblers, snipe and many other birds crisscross the sky. Welsh mountain ponies have been introduced to help manage the reserves by selectively grazing the vegetation.

The southern tip of Anglesey has the fourth and largest NNR, Newborough Warren – Ynys Llanddwyn. This large complex of sand dunes nestled between the Malltraeth estuary and the southern mouth of the Menai Strait demonstrates the full range of dune development, from beaches and active dunes of bare sand to more highly vegetated stabilised areas with wetlands. The varied habitats provide home to many rare and unusual plants and invertebrates. The reserve also incorporates Llanddwyn Island, a popular walking place that is known not only for its wildlife, but also its interesting geology (see Geology, page 27) and lighthouses (see Lighthouses, page 45).

Besides these major reserves, there are over sixty Sites of Special Scientific Interest – areas that have been notified as being of special interest under the Wildlife and Countryside Act 1981. Their protected status helps preserve their unique plants, animals or geological features, but many of them are on private land with no public access. However, some, like the Malltraeth Marsh/Cors Ddyga reserve, the Cemlyn Bay shingle beach and tern colony, and the Valley Lakes, are popular walking destinations. A full list of nature sites, with details and maps, can be found at the website angleseynature.co.uk.

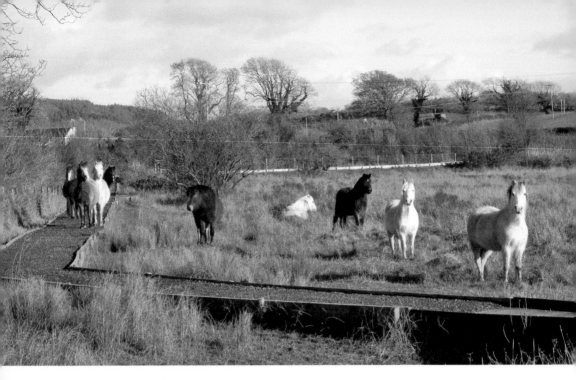

Above: Welsh mountain ponies on the boardwalk at Cors Bodeilio.

Left: Northern Marsh Orchid (*Dactylorhiza purpurella*) at Newborough Warren.

O

Over the Strait

Many millennia ago, the Isle of Anglesey was not an island, but part of the Welsh mainland. During the last ice age, glaciers from the north-east carved out a valley along a geological fault. As the ice melted and the sea levels rose the higher tides began encroaching on either end of this valley. By around 5,000 years ago Anglesey was fully cut off from the mainland. The Menai Strait had formed.

Humans had recolonised Anglesey in the time between the ice retreat and the flooding of the strait, so after this they were cut off. But numerous finds of stone axes quarried from further along the North Wales coast show that they were able to regularly cross the strait, probably in small skin-covered boats. Finds of flint axes from further afield and later influx of newly developed technologies in tools, pottery and burial tomb construction show that Anglesey was anything but isolated.

The first historical record of crossing the strait is the dramatic invasion of the island by the Romans in AD 60. The Roman historian Tacitus wrote of the battle on

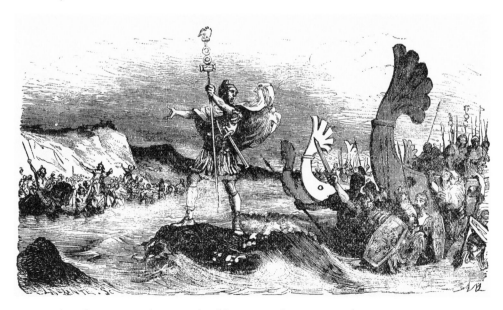

Romans invading Britain. (From *Ridpath's Universal History*, 1897)

the strait, led by Suetonius Paulinus. He had boats built, with flat bottoms to cope with the shallow waters, to carry the infantry across.

During the wars between Edward I and Llywelyn ap Gruffudd in the thirteenth century, another invasion attempt was made across the strait. Anglesey had been captured in 1282 by one of Edward's armies, and they drew up plans to cross the strait and take over Llywelyn's base on the Gwynedd side. They constructed a 'bridge of boats' – a pontoon bridge that would allow the army to rapidly cross. However, Llywelyn was prepared, and as the army began to cross his men emerged from hiding to block their way. The English troops were forced back to the strait, but by this time the rising tide had cut them off from the bridge. They tried to wade back to the bridge, but their heavy armour caused most to sink and drown, with over 300 dying.

By this time regular ferries had begun to ply the waters of the strait. A ferry was running from Llanfaes (near present-day Beaumaris) from at least 1292, with documents from that time showing the boat was owned by the king, Edward I, and was run by five ferrymen. This crossed the strait at low tide to the Lavan Sands, across which the passengers then walked to the shore near Aber. Also in 1292, the sherriff's accounts show another ferry, known as *Porthesgob* (or the Bishop's Ferry) was running from Garth Point near Bangor to various points between Beaumaris and Cadnant.

A third ferry ran from Porthaethwy (Menai Bridge). It usually docked on the Anglesey side on the shore below the old Ferry House (later known as the Cambria Inn, now the oldest house in the town, dating from the late seventeenth century). It originally went

Ferries landing at the Ferry House/Cambria Inn (right), *c.* 1829. (H. Gastineau)

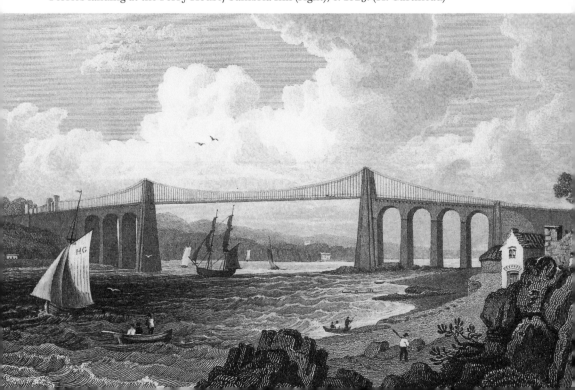

straight across, docking near the present-day house Bodlondeb, but after the George Hotel was built around 1770 that became the main destination.

In the central part of the strait, the Swellies, the currents are too strong and unpredictable for ferries to regularly run, but at the western end two more routes were developed. The Llanidan/Moel y Don ferry was first recorded in 1296 and probably originally ran from the shore near Llanidan Old Church, going straight across to Llanfair Isgaer Church. By the sixteenth century it had shifted to Moel-y-Don, possibly because of sandbars developing near Llanidan, and landed at Felinheli. Finally, ferries ran from Abermenai Point, off of Newborough Warren, across to Morfa Dinlle, the site of Fort Belan, and from Tal-y-Foel to Caernarfon.

The Act of Union between Britain and Ireland in 1800 meant that traffic across the strait and Anglesey to Holyhead Port increased dramatically. Many plans were drawn up to bridge the strait, but the one by Thomas Telford finally got the nod from Parliament. His was for a groundbreaking suspension bridge; its main 176-metre-long span flying 30 metres above the water surface was by far the largest in the world at the time. The first stone for the towers was laid on 10 August 1819, and it was open to traffic on 30 January 1826.

Soon after the opening railways began to stretch their way across the country, and the need for a rail crossing of the strait became clear. A Parliamentary Act in 1844 authorised the building of a railway to Holyhead, and Robert Stephenson was chosen to develop the route and build the bridge. Like the Suspension Bridge, the

Menai Suspension Bridge.

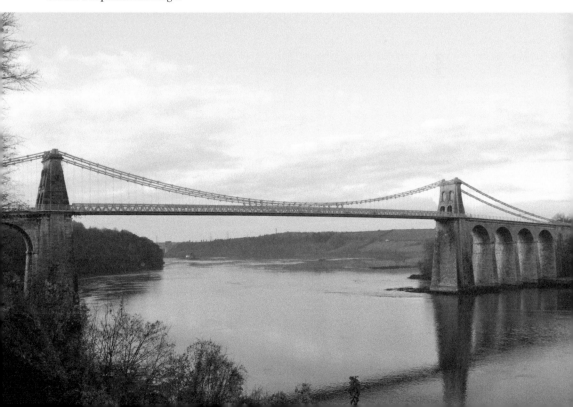

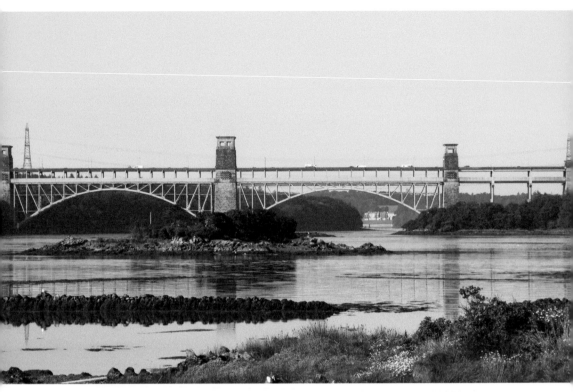

Britannia Bridge.

new rail bridge had to be 30 metres above the water to allow tall sailing ships to pass underneath. Following Telford, Stephenson turned to an innovative solution; the trains would pass through rectangular tubes constructed of wrought-iron plates. After four years of construction, the Britannia Bridge was opened on 5 March 1850. After serving well for 120 years, a disastrous fire occurred in 1970, destroying the tubes. But, with the addition of arches, a new rail deck was constructed with a road deck above. The Britannia Bridge now carries most of the road traffic across the strait.

P

Prehistoric Monuments

The very earliest people known to have lived on Anglesey during the Mesolithic (around 8000 BC) left little behind. All that has been found to tell us the story of these hunter-gathers are a few arrow points and the leftover flakes of flint produced in making the arrows. By this time forests had replaced the barren landscapes left by the Ice Age glaciers, and the Anglesey residents would have hunted deer, boar, oxen and bison, as well as gathering plants and shellfish and trapping fish.

Around 4000 BC the switch was made to farming, using techniques and crops that originated in the Near East, probably brought by a new wave of settlers. This more

Bodowyr Burial Chamber.

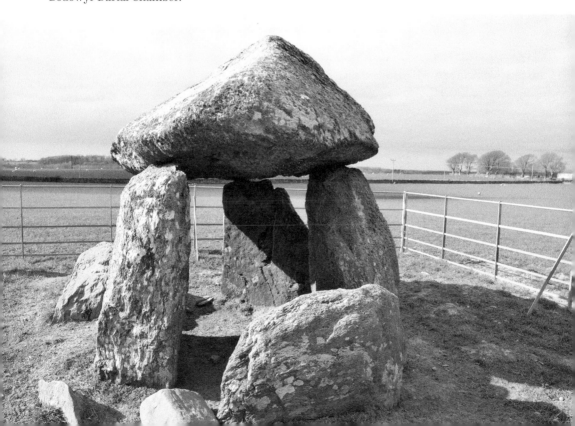

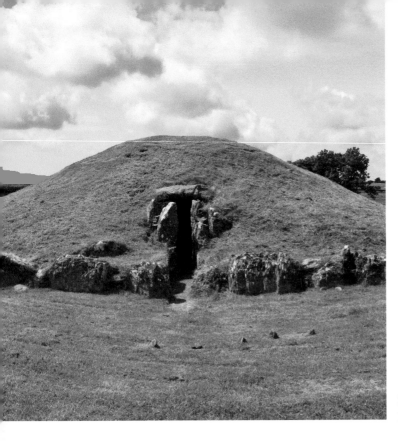

Bryn Celli Ddu
passage tomb.

settled way of life in the Neolithic led to permanent structures being built, many of
which can still be seen on the Island. Most prominent are the burial tombs.

There are around sixteen tombs still visible around the island, but there would have
once been many more. They consist of a central chamber with some sort of narrow
passage or larger portal for access. They would have been covered by a mound of earth
or stones, but these have disappeared in all cases except where the mound has been
reconstructed by early archaeologists.

These tombs would serve as a burial place for the dead and a shrine to the ancestors.
The bones of numerous individuals have been found in these tombs (more than fifty
in one) – sometimes cremated, sometimes not. Also uncovered were pottery and other
items such as arrowheads and pins made of antler or bone. There are signs of ritual
use in some, with evidence of fires having been set inside the tomb. In Barclodiad y
Gawres, the fire pit was found to contain unburnt bones from a number of different
animals, including wrasse, eels, frogs, toads, snakes, mice and hares, suggesting the
fire was quenched with a 'witches brew' of a stew. This was then carefully covered
with pebbles and limpet shells.

Most of the tombs around Anglesey are just bare rock, sometimes completely
collapsed, but two have been reconstructed with mounds similar to their original
appearance. The previously mentioned Barclodiad y Gawres was initially thought
to have been a pile of stones or perhaps remnants of stone-lined burial pits, but
excavations in the early 1950s revealed its true structure, as well as several decoratively
carved stones. It was then reconstructed and covered with earth. Bryn Celli Ddu was

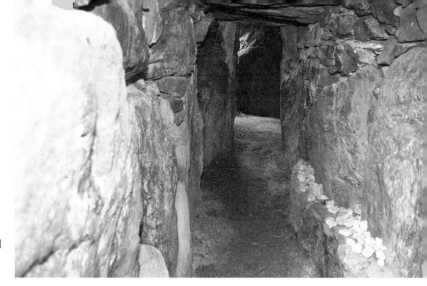

View into the passage and central chamber of Bryn Celli Ddu.

excavated and reconstructed in the 1930s, with the mound covering just half of the original expanse, so that light could be allowed into the central chamber.

Other prehistoric features commonly seen around Anglesey are the standing stones. Little is known about these. A few have pottery sherds buried underneath them that give an indication of their age (early Bronze Age, around 2000 BC), but most have no clues of their age or purpose. Indeed, some standing stones were actually erected in the eighteenth century AD by farmers following suggestions by agricultural improvers that they provide a place for cattle to scratch themselves. The ancient ones have been suggested to have been centres of religious ceremonies, monuments for remembrance of certain people of events, or boundary markers, but we have no way to know their true purpose.

Mein Hirion standing stones, near Llanfechell. This is an unusual site with three stones, whereas most have just a single one.

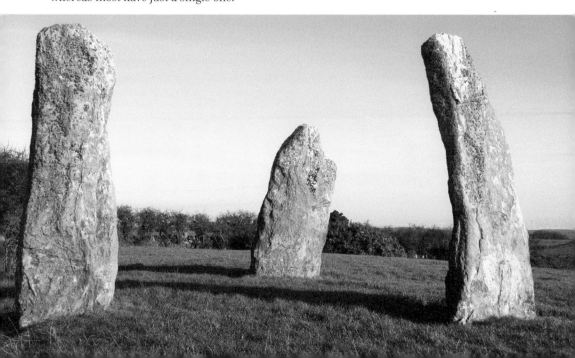

Quays

Being an island in the Irish Sea, travel and transport by sea has been strong feature of life on Anglesey. Its rocky, undulating coast also provides a plethora of bays and inlets for boats to shelter and launch. Over 165 place names around the coast have the element *porth* in them (such as Porthaethwy/Menai Bridge, Porth Swtan, and Borthwen), which is the Welsh word for 'landing place' or 'harbour' (derived from the Latin word *portus*). A number of other wider bays have Welsh names based on *traeth* ('beach' or 'sands'), including Traeth Coch/Red Wharf Bay and Traeth Lligwy.

Many of these small bays are now quiet places where one can escape the crowds, but centuries ago they may have been busy places. In the days when the state of the roads was very poor, small boats would have sailed in and out of these ports. They may have been landing freshly caught fish or shipping them back out after preparing and salting for preservation. They may have been bringing in manufactured goods or exporting excess grain to other ports. The boats would have been drawn up on the beach, like you can still see today at Moelfre and Red Wharf Bay. But as the economy and population grew some ports began to grow and develop more permanent piers and quays to accommodate greater traffic.

Today Holyhead is by far the largest port, hosting several ferries that daily cross the Irish Sea to Dublin, as well as cruise liners, fishing boats and pleasure craft. But it can

Boats at low tide at Red Wharf Bay, near the Ship Inn.

Holyhead Port, with Salt Island to the right, where two ferries are docked.

trace its history back to the Romans. The church of St Cybi stands inside the walls of an old Roman fort, built as a naval base towards the later days of their occupation. It is an unusual three-walled fort, with the eastern side open to the sea and their ships. It was abandoned around AD 390, after which the area was just a tidal creek, possibly home to a few boats used by local fishermen. During the reign of Elizabeth I her efforts to reinforce her control over Ireland led to a regular postal system to be set up around 1575 to relay messages to her Lord Lieutenant in Dublin. By 1660 three packet boats were sailing between Holyhead and Dublin, and inns were being built to house travellers waiting for passage. There were no quays or piers; the boats would anchor in the harbour and sit on the sand when the tide went out.

As traffic across the sea increased after the 1800 Act of Union, demands for better facilities grew. In 1810 construction of a new pier on Salt Island was begun, along with a Harbour Office and Customs House. This work was completed in 1821. The arrival of the railway in 1848 prompted further work on the harbour. The waters of the inner harbour once lapped up close to the buildings where the war memorial stands today, but the area between there and Salt Island was infilled to provide for the railway and road to go to Salt Island, and later even more to build the current railway station.

Other piers and quays cropped up around the Anglesey coast through the years. The development of the narrow inlet at Amlwch was prompted by the shipping of copper from Parys Mountain (see Amlwch and the Copper Kingdom, page 6). Further along the north coast, in the nineteenth century, a brick works was founded at Porth Wen and a porcelain factory at Porth Llanlleiana. Both took advantage of locally quarried materials and both had quays to cater for the ships that carried the products to market. In the late eighteenth century a pier was built in Cemaes Bay to provide a harbour and quay for the local herring fishing boats, as well as for exporting the salted herring and locally produced bricks.

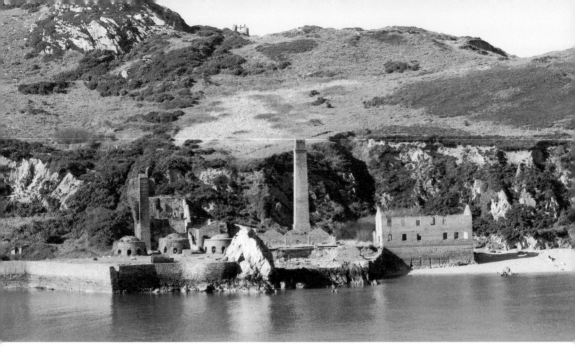

Porth Wen brickworks and quay.

The Menai Strait had several landing places for the ferries from the mainland through the centuries (see Over the Strait, page 56) but two in particular were more fully developed with quays and piers in the nineteenth century. In Menai Bridge, after the opening of the Menai Suspension Bridge in 1826, shopkeeper Richard Davies built warehouses and a quay at Prince's Pier to provide berthing places for ships bring in goods and timber to the rapidly expanding town, as well as for shipping out slates from the mainland around the world. Another stone pier, St George's Pier, was soon built nearby. In 1840 another pier was built in Beaumaris. Towards the end of the century all these piers were refurbished and extended to accommodate the growing trade in pleasure steamers bringing tourists from Llandudno, Liverpool and the Isle of Man.

Prince's Pier, in the shadow of the Menai Suspension Bridge.

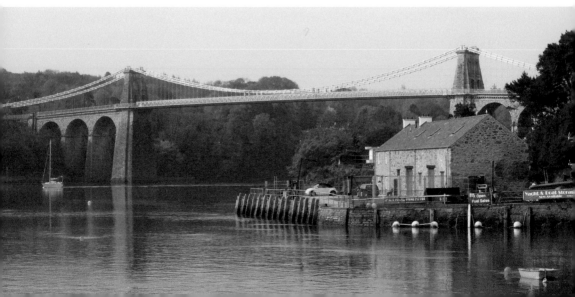

R

RNLI Lifeboats

As an island Anglesey is usually surrounded by boats and ships: ones sailing from Holyhead to Dublin, or passing by bound for Liverpool and other ports, or local pleasure and fishing craft. But bad weather and rocky coasts pose threats to these vessels, and Anglesey has been the site of scores of shipwrecks. Communities have always banded together to rescue those in trouble offshore, but in the early nineteenth century these efforts became formalised as volunteer-run lifeboat stations began to be set up.

On 26 March 1823 the packet *Alert*, sailing from Howth in Ireland to the Wirrel on a calm day, drifted too close to the West Mouse island off the north coast of Anglesey, ran onto the rocks, was holed and sank. The 140 passengers and crew were all lost. The tragedy was witnessed from the shore by the new rector of Llanfairynghornwy, Revd James Williams, and his wife Frances (great-grandparents of the Anglesey artist Kyffin Williams – see page 41). They vowed to do all they could to help those caught in similar tragedies and were instrumental in forming the Anglesey Association for the Preservation of Lives from Shipwreck in 1828. Their first lifeboat, a six-oared, lightweight and buoyant boat, was stationed in Cemlyn Bay that same year. In the next couple of years this was followed by two more in Holyhead and Rhoscolyn, then later ones at Penmon and Llanddwyn.

The old lifeboat station at Rhoscolyn.

The Beaumaris Atlantic 85-class lifeboat *Annette Mary Liddington* launching after being transported from the boathouse by tractor.

In 1824 William Hillary, a Yorkshireman who had settled on the Isle of Man and become equally concerned at the loss of life on the Irish sea, formed the National Institution for the Preservation of Life from Shipwreck. This was renamed the Royal National Lifeboat Institution (RNLI) in 1854. The following year the RNLI took over the running of the Anglesey Association's lifeboats, and subsequently added new stations at Moelfre (1854), Bull Bay (1868), Rhosneigr (1872), Cemaes (1872), Beaumaris (1891), Porth Ruffydd (1891) and Trearddur Bay (1967). Many of these closed in the early twentieth century, but four remain: Moelfre, Holyhead, Beaumaris and Trearddur Bay.

Although all these stations have been served by amazingly brave volunteers who have saved countless lives, one stands out in Anglesey's history. Richard (Dic) Evans was born in Moelfre in 1905, into a family of merchant seamen and lifeboat volunteers. One of his ancestors was even involved in the rescue after the famous wreck of the *Royal Charter*, a gold-laden ship arriving from Australia in October 1859 when it sank in a fierce storm just off the Moelfre coast.

Exactly 100 years later, Evans was the coxswain of the Moelfre lifeboat when the *Hindlea* lost power and drifted towards the rocks at the same spot. The lifeboat was launched and soon drew close to the ship; however, the storm was so powerful it took the brave crew several attempts to get alongside the ship. Each time one of the *Hindlea* crew members was able to jump into the lifeboat before it was swept back, until all eight crew were rescued. The now-abandoned ship wrecked on the headlands forty-five minutes later.

For this remarkable rescue Dic Evans was given the RNLI's Gold Medal for Gallantry – the first of two of these rarely given awards that he was to win, alongside many other honours. Four other members of the crew were also given silver or bronze medals. Evans served as a volunteer for fifty years, was involved in 179 launches and the saving of 281 lives. He died in 2001 and a statue in his honour was unveiled by the Prince of Wales in 2004 near the lifeboat station.

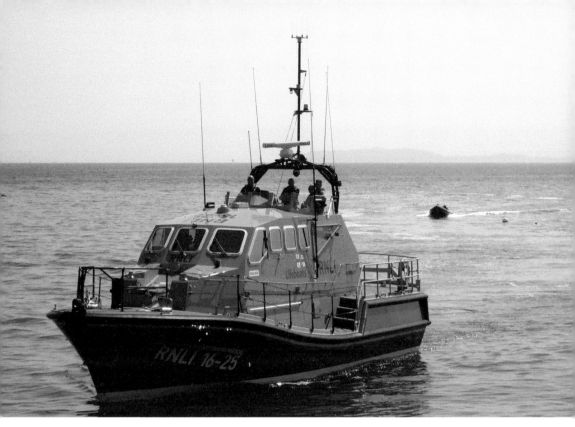

Above: The Moelfre-based RNLI Tamar class lifeboat *Kiwi*, followed by the D-Class inshore lifeboat *Enfys*, in Moelfre Bay.

Right: Statue of Dic Evans at Moelfre, by sculptor Sam Holland.

Saints

Most of the churches on Anglesey (see Churches, page 12) are dedicated to saints. Many are named after saints known and revered worldwide, such as St Mary (e.g. Llanfair Pwllgwyngyll, Llanfair Mathafarn Eithaf, Llanfairynghornwy, etc.) and St Michael (Llanfihangel Tyn Sylwy, Llanfihangel Esceifiog, etc.). One of the oldest places of Christian worship on the island is dedicated to the Irish patron saint St Patrick (Llanbadrig, near Cemaes), and the Church in the Sea, St Cyfan's in Llangwyfan, is thought to be dedicated to another Irish saint, St Kevin of Glendalough in Co. Wicklow.

However, many of the churches are named after local saints, holy men or women who settled down to a life of prayer and reflection, fostering the development of a centre of worship near their retreat. Little is known of many of them except their names. But a few are dedicated to saints with rich stories. The story of one of the most famous Welsh saints, St Dwynwen, who founded a church on Llanddwyn Island, is recounted in X – A Kiss for St Dwynwen's Day (see page 87).

Murals of Sts Seiriol and Cybi in Holyhead at the entrance to the Celtic Gateway pedestrian bridge, by artist Gary Drostle.

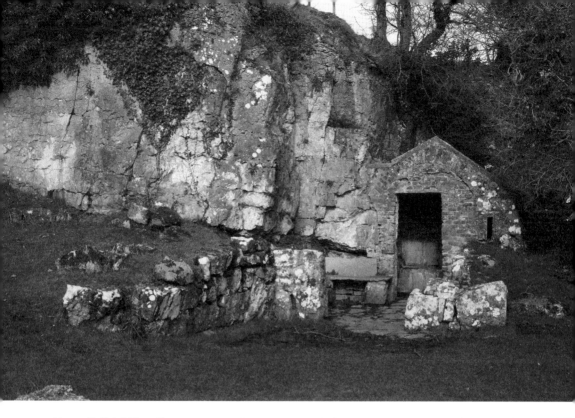

Above: St Seiriol's well, Penmon.

Right: Causeway leading to Llanbeulan Church.

The sixth century saw the foundations of two monastic communities at opposite ends of the island by two friends, Cybi and Seiriol. St Cybi's monastery was at the heart of what is now Holyhead (its Welsh name, Caergybi, comes from the saint) and St Seiriol established a community at Penmon, at the north-east end of the island. According to legend, the two saints used to meet weekly at Llannerch-y-medd, near the centre of the island. St Cybi would walk from Holyhead, facing the rising sun in the morning and the setting sun in the evening. St Seiriol, travelling in the opposite direction, would have the sun to his back during his journey. They were thus known as Cybi the Dark (since he was tanned during his journey) and Seiriol the Fair.

One of Cybi's followers, St Peulan, founded his own church at Llanbeulan, possibly around AD 630. He was the son of Paulinus, a saint from South Wales who had taught St David. His sister Gwenfaen founded a church in Rhoscolyn, where her holy well can be found on top of the nearby cliffs. His brother Gwyngeneu also founded a church nearby, on Holy Island, but no trace of that one exists. Another follower of St Cybi, Maelog, son of King Caw of Strathclyde, also founded a church on Anglesey at Llanfaelog.

A poem by the sixteenth-century bard Gwilym Gwyn tells the story of St Eilian, to whom the church of Llaneilian is dedicated. He was sent by the pope from Rome to Anglesey as an emissary to Cadwallon Lawhir, ruler of Anglesey. Eilian was bringing a number of oxen as well as his household, and Cadwallon seized the animals. In retaliation Eilian struck the king blind, then offered to restore his sight in return for as much land as a deer could run while being pursued. He then established a church on the site, around AD 450.

St Gwnefaen's holy well, near Rhoscolyn.

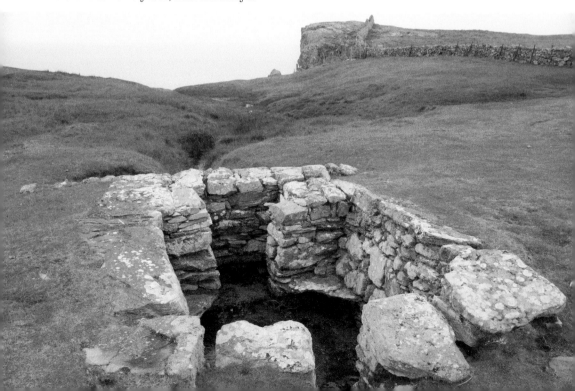

Transport

From the time that humans first developed settlements, pathways of some sort developed to connect these to other nearby places. These mostly would have been just well-worn tracks, but in some cases there were specific structures built, such as wooden trackways across wetlands. There is some evidence that Iron Age people in Britain constructed metalled roads (ones surfaced with small stones to make them more durable), but the first widespread construction of proper roads arrived with the Romans.

A network of roads was built in North Wales to connect the various Roman forts such as Segontium (Caernarfon) and Canovium (Caerhun). Until recently the only known Roman remains on Anglesey were the naval fort at Holyhead and the nearby watchtower on Holyhead Mountain. No roads had been identified. However, in 2009 the remains of a Roman settlement were discovered on the Menai Strait, near the Sea Zoo and across the strait from Segontium. The road here was a typical wide Roman road, and it is thought that it may have continued across Anglesey to Holyhead, but much more archaeological work will be needed to prove this.

After the Romans left, travel on Anglesey continued as before, using the ancient tracks. Into the seventeenth and eighteenth centuries, the development of wider trade and a postal system meant that more attention was focused on the roads. Maps at this time began to show major roads and give directions and distances between major centres. However, the condition of the roads was usually poor, and legislation to force local parishes to maintain roads had little effect. In the mid-eighteenth century the first turnpike trusts were set up in Wales to build, improve and maintain major roads. These trusts, formed by Acts of Parliament, were composed of trustees drawn from the local gentry, merchants and clergy. They then employed people to oversee the roads, and road users were charged a toll to fund the maintenance. This system did eventually bring about greatly improved road quality, but also led to much resentment at the charges, resulting in the Rebecca Riots in west and Mid Wales in 1839–43.

The main post road across Anglesey to Holyhead Port is shown on the adjacent map. It started at the ferry crossing to Beaumaris from across the Lavan Sands, then ran through Llansadwrn, Rhoscefnhir and Ceint, on to Llangefni, Bodedern

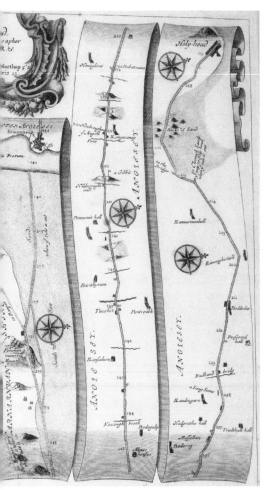

Above left: Section of Ogilby's 1675 strip map, showing the road from Beaumaris (top left) to Holyhead (top right).

Above right: Quiet lane between Rhoscefnhir and Ceint, which used to be the main post road across Anglesey. On the map above, this section would be in the centre of the middle strip, near 'Penmenis hall' (a misspelling of Penmynydd Hall).

and Llanynghenedl before crossing to Ynys Cybi at Four Mile Bridge and onward to Holyhead. Later, when more ferries crossed further down the strait at Porthaethwy, the post road shifted to go from there, though Penmynydd, to Llangefni and onwards. This road became a turnpike in 1765.

When Thomas Telford was tasked with improving the route across Wales to Holyhead Port in the early 1800s, he not only built the Menai Bridge and upgraded the routes through the mountains, he also built an entirely new road across Anglesey. The old road followed ancient meandering paths, up and down hills. He selected a new route that was much more direct, and on the flat as much as possible, greatly

reducing the travel time required. This new route, which is now called the A5, was also a toll road, and Telford designed six unique octagonal toll houses, five of which still stand along the road.

Soon after this the railways began expanding across Britain, and in 1848 a railway from Chester to Bangor, and then from Llanfairpwll to Holyhead, was opened. The completion in 1850 of the Britannia Bridge across the Menai Strait allowed these two sections to be joined. The railways brought more people faster to the Holyhead port, for travel on to Ireland. They also opened up opportunities to bring travellers to the island itself, and transport products from Anglesey to the wider world. In 1865 the Anglesey Central Railway was opened. This was a branch line of the main railway, heading off north from Gaerwen through Llangefni to Amlwch. A few decades later, in 1908, a branch of this was opened, running from Holland Arms to take tourists to Benllech and Red Wharf Bay.

Several other railways were proposed on the island, including one from Menai Bridge to Beaumaris and Penmon, another from Cemaes to Valley, and two ideas to run trains from Gaerwen to the southern Menai Strait shore to link up with ferries to Caernarfon. None of these came to fruition. The branch line to Red Wharf Bay was short-lived, closing to passengers in 1930, but continuing to carry freight for another twenty years.

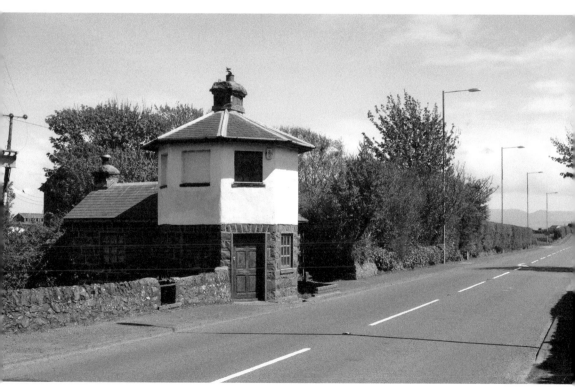

Telford-designed toll house on the A5 near Gwalchmai.

Rail enthusiasts watch the Flying Scotsman steam engine crossing the Malltraeth viaduct on the way to Holyhead in 2016.

The Amlwch passenger line was closed in the wide-ranging Beeching cuts in passenger train routes in 1964. However, it continued carrying freight, mainly chemical tankers from the Octel bromine extraction plant in Amlwch. These tankers were transferred to the road in 1993 and the line ceased to be used. Ever since then the tracks have remained intact, and many enthusiasts have worked on plans to reopen it as a heritage railway. Others have called for it to be turned into a walking and cycling path. Either way, opening up this path through a beautiful part of the island would be a great draw to locals and tourists alike.

U

Uxbridge, Earls of

One of the grandest houses on Anglesey, Plas Newydd, near Llanfairpwll, has a long history dominated by two families, the Baylys and the Pagets. The current house mainly dates to the late eighteenth century, but the history of the estate goes back to the thirteenth century, when a house called Llwyn-y-Moel stood on the site. In the fifteenth century, the enlarged estate belonged to the Gwilym ap Gruffydd of Penrhyn. His great-granddaughter married Lewis Bayly, the Bishop of Bangor in the early seventeenth century. The estate passed through the Bayly family to Sir Nicholas, 2nd Baronet of Plas Newydd, who in 1737 married Caroline Paget.

Caroline was descended from William Paget, a statesman in the court of Henry VIII who was created 1st Baron Paget de Beaudesert. Beaudesert is an estate near Cannock Chase in Staffordshire, which was granted to William by the king and became the family seat for centuries. His descendants straddled various religious and political divides through the years. The 3rd Baron was a Catholic exile who was involved in a plot to assassinate Elizabeth I and place Mary, Queen of Scots on the throne. He lost

Plas Newydd.

his title as a result, but his son William, a staunch Protestant, had the title restored to him. His son, also William, sided with the Parliamentarians in their disputes with Charles I, but switched to the Royalist side when it was clear that Parliamentarians were going to turn to arms.

The 6th Baron, another William, followed in his ancestor's statesman footsteps by being the ambassador to first Vienna, then later the Ottoman Empire. His son Henry, the 7th Baron, after a distinguished political career, was appointed Envoy Extraordinary to Hanover. However, he would not go unless he was made an earl. Queen Anne refused, but three months later she died and was replaced on the throne by the Elector of Hanover, who became George I. He duly elevated Henry in the peerage as the Earl of Uxbridge.

The title Earl of Uxbridge was initially short lived. It passed to Henry's grandson, also Henry, but the 2nd Earl (and 8th Baron Paget) died in 1769 unmarried and

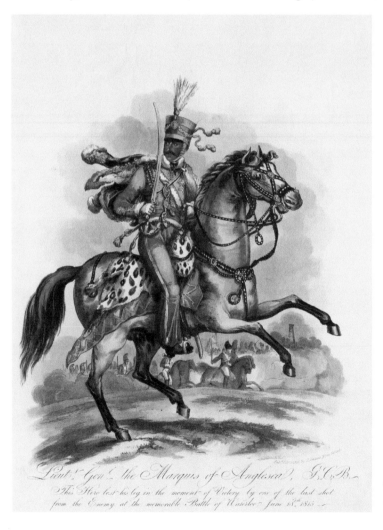

Henry Paget, 1st Marquess of Anglesey. (Joseph John Jenkins/ National Library of Wales)

with no heirs. The earldom became extinct, but the title of Baron Paget continued. The 1st Baron had made sure that the title could pass down through the female line if needed. The next in line in the Paget family was Caroline, Henry's second cousin once removed, who as mentioned above married Sir Nicholas Bayly of Plas Newydd. Thus, their son Henry Bayly became the 9th Baron Paget. He also changed his surname to Paget and, when his father died in 1782 he became owner of Plas Newydd as well as Beaudesert and various other properties in Dorset, Somerset and Ireland. Two years later the earldom was revived and he became the 1st Earl of Uxbridge of the second creation.

Henry's son, yet another Henry, is probably the most famous of the family. In his twenties he entered Parliament as MP for Caernarfon, but soon became a military man. When the French Revolutionary Wars broke out he raised a regiment of volunteers from Staffordshire, the 80th Regiment of Foot, which fought in Flanders under the Duke of York. He rose through the ranks and was soon appointed Lieutenant-Colonel of the 7th Light Dragoons, which became one of the finest cavalry units in the country. Over the years it saw action in Holland and Spain.

In 1815, after the escape of Napoleon from Ebla, Henry became second in command to the Duke of Wellington, as commander of the allied cavalry raised to defeat Napoleon. At the close of the Battle of Waterloo Henry's leg was hit by a cannonball. The famous, but probably apocryphal, exchange between the duke and the earl then took place: 'By God, sir, I've lost my leg!' with Wellington replying, 'By God, sir, so you have!' Three weeks later he was made the Marquess of Anglesey by the prince regent (later George VI), who declared him 'his best officer and his best subject'. His military career ended, but he continued in politics and became Lord Lieutenant of Ireland. He died in 1854, leaving eighteen children and seventy-three grandchildren.

The subsequent generations of marquesses followed the usual pattern of the aristocracy: sitting in Parliament, being Privy Councillors, Lord Chamberlains and Lord Lieutenants, but none particularly distinguished or well known until the 5th Marquess. Henry Cyril Paget was born in 1875, but his mother died when he was two years old. He was brought up in Paris by his mother's sister, Edith Marion Boyd, who married the brother of the famous actor Benoît-Constant Coquelin (leading to rumours that Benoît was Henry's real father).

From an early age he was fascinated by the theatre, and when he inherited the title and estate in 1898 he soon began transforming it to match his interests, renaming the house Anglesey Castle and turning the chapel into a theatre. He founded a theatre company, staging lavish productions of song and dance, usually with himself in the lead role in flamboyant costumes. This led to him being known as the 'Dancing Marquess'.

Although he inherited several estates providing a vast income, his lavish spending on his wardrobe and jewellery led him to accumulate huge debts and he became bankrupt by 1904. The 'Great Anglesey Sales' were then held, selling off over 17,000 lots of his belongings to pay off his debtors. He died the next year and the estate

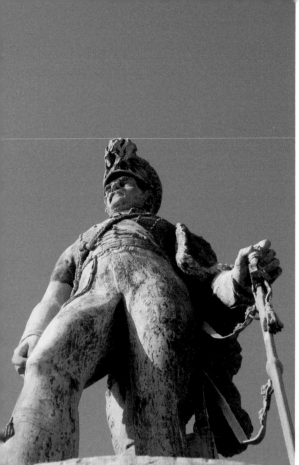

Above left: Statue of the 1st Marquess of Anglesey, on top of the Anglesey Column.

Above right: Henry Paget, 5th Marquess of Anglesey. (John Wickens)

passed to his cousin, Charles Henry Alexander Paget, who converted the theatre back to a chapel, destroyed all the 5th Marquess' papers, and sold off the family estate in Beaudesert.

The military connections of the family returned with the 7th Marquess. He was a major in the Royal Horse Guards, fighting in the Second World War. He is best known as a well-respected military historian, writing a massive series *A History of the British Cavalry*, Volumes I–VIII, as well as a biography of his ancestor, *One Leg: The Life and Letters of 1st Marquess of Anglesey*. In 1976 he turned the house over to the National Trust, who now run it as one of the most popular attractions on Anglesey. He continued living in a separate section of the house until his death in 2013. His study where he wrote all his books can now be viewed at the house as he left it, a glorious cacophony of stacks of books and papers, drawing tools and CDs of classical music.

V

Vikings

After the departure of the Romans in the fourth century AD, and a subsequent period of rule by Irish chieftains, Anglesey and Gwynedd came under the rule of Welsh kings, such as Maelgwn in the sixth century. Also at this time Christianity developed an increasing influence on society, and monasteries and churches sprang up around the island. By the ninth century, the growing wealth of these religious houses, kept in relatively undefended centres of worship, began to attract the attention of the Norsemen who had settled just 60 miles across the sea in Dublin.

Viking warriors face off against native Welsh in a re-enactment battle during the Amlwch Viking Festival in 2002.

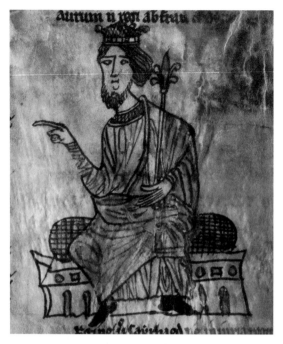

Hywel Dda, depicted in the manuscript *Laws of Hywel Dda*.

The first known Viking raid of Anglesey came around AD 853, with one two years later lead by the Danish leader Gorm. He was killed by Rhodri Mawr, the king of Gwynedd who also ruled over Powys and later much of Mid Wales. He and his sons held off the Vikings for many years, but in AD 903 a Viking band led by Ingimund, who had been expelled from Dublin, invaded Anglesey. However, they were soon ousted, probably by Clydog, younger brother of Hywel Dda, the future ruler of much of Wales. Ingimund and his followers went on to settle in the Chester area.

The strong but diplomatic hand of Hywel Dda meant that conflict with the Norsemen during his reign were rare. However, after his death in AD 950 Viking raids resumed. In AD 961 St Cybi's Church and monastery at Holyhead was sacked. This was followed in the next few years by an attack on the royal court in Aberffraw and the pillaging of the monastery at Penmon. These raids focused not only on stealing the gold and silver wealth and food supplies but also enslaving the local population. In AD 987 records show that 2,000 Welshmen were taken captive in a raid, with king Maredudd ab Owain paying a penny a head ransom to get them back.

Further Viking raids occurred on Anglesey in AD 994 and AD 999, but after this the powerful kings of Gwynedd were able to keep Viking aggression at bay, and even form diplomatic alliances with them to counter the threat from the Normans. Indeed, Gruffydd ap Cynan, King of Gwynedd (and great-grandfather of Llywelyn the Great), had a Norse mother and close family connections in Dublin, which he visited frequently and where he may have been born. He struggled regularly with the Normans over the rulership of North Wales, often retreating to Ireland when events turned against him.

In 1098 the Norman earls of Chester and Shrewsbury regained the upper hand after four years of Welsh rule of Gwynedd and forced Gruffydd to yet again flee to Dublin in a small boat. However, the tides turned just a few days later when Magnus Barefoot, King of Norway, sailed into the Irish Sea, seeking to expand his influence southwards from the Western Isles of Scotland. With his fleet of six ships he sailed into the north-east end of the Menai Strait. The Normans, based in Aberlleiniog Castle near Llangoed, refused to allow them to land and began battle by shooting arrows from the shore at their ships. As the battled raged, Hugh of Montgomery, the Earl of Shrewsbury, received an arrow through the eye slit of his helmet and was killed. By most accounts the arrow was fired by Magnus himself. The Normans then pulled back and eventually retreated to England. Magnus claimed Anglesey as part of his possessions, but never actually settled there, and he soon allowed Gruffydd to return from Ireland to regain his kingship and consolidate his rule until his death in 1137. They remained on friendly terms and in 1102 Gruffydd allowed Magnus to harvest timber from Anglesey for his fortresses on the Isle of Man.

Red Wharf Bay, in the north of Anglesey, is popularly supposed to have got its name (Traeth Coch in Welsh, 'Red Beach') from a Viking battle there that left the sands soaked in blood. This battle is often said to have been in 1170, but this is actually the date of a battle nearby between the sons of king Owain Gwynedd over who would inherit the kingdom. However, the wide shallow bay seems an ideal location for Viking landings, and indeed archaeological evidence does show Viking activity in the area. In the late nineteenth century a hoard of five silver armbands was found in a quarry overlooking the bay near the Din Sylwy hill fort (also known as Bwrdd Arthur). These are in fine condition and decorated with a variety of patterns commonly seen in Viking works. They are similar in style to objects found in the Cuerdale Hoard in Lancashire and are thought to have been possessions of the Vikings who were expelled from Dublin in AD 903, so may have been buried by Ingimund himself during his short period on Anglesey.

Red Wharf Bay.

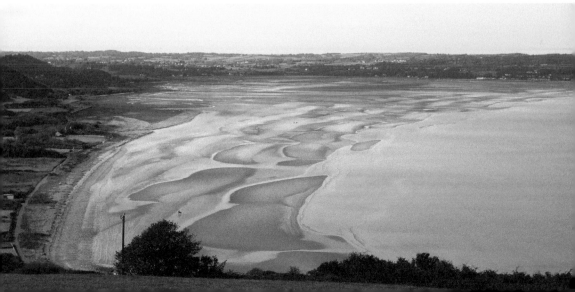

Viking armbands found near Red Wharf Bay.
(Royal Commission on the Ancient and Historical
Monuments of Wales)

Close to Red Wharf Bay was another of the rare examples of archaeological evidence of the Vikings. In 1989 a single Anglo-Saxon penny was found in a field near the village of Llanbedrgoch. Three years later metal detectorists found several more coins, plus lead weights similar to those used by Viking traders. Initial excavations of the area revealed evidence of a house, which has been radiocarbon dated from the eight to tenth centuries AD. Over the years further excavations have been done, revealing other buildings as well as a variety of intriguing artefacts from the Viking era, including silver broaches and ingots, bronze buckles, glass beads, iron knives, as well as stone, bone and antler tools. They all give a rich view of life during this time. In particular, the Viking weights, along with a piece of an Islamic coin from central Asia, show that this was a centre of widespread trade.

Also found at the site have been the burials of a number of men, women and adolescents. Their bodies were not oriented east–west, as is normal for Christian burials, and one grave had a young boy lying underneath a young adult, who appeared to have died a violent death. It was originally thought that these might have been victims of Viking raids. However, isotope analysis of the skeletons shows that many of them had previously lived in either northwest Scotland or Scandinavia, suggesting they were actually Vikings themselves.

W

Windmills

Anglesey, being an island on the west coast of Britain, can sometimes be a very windy place. The effects of the strong westerly winds can be seen in the numerous windswept trees around the island that grow in a distinctly easterly direction.

The abundance of wind provided a useful source of energy and during the eighteenth and nineteenth centuries numerous windmills were built around the

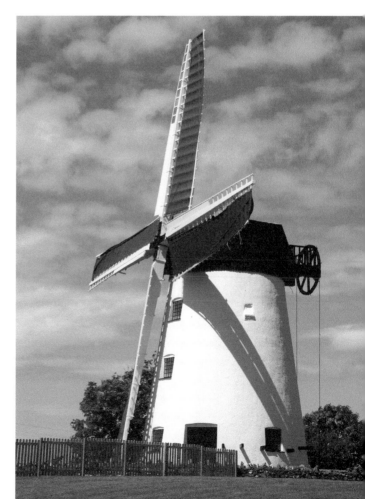

Melin Llynnon, Llanddeusant.

island. Almost fifty are known to have been built. Many of these are now in disrepair or have disappeared; however, some have found new life.

Many of the existing windmills were built during periods of drought in the 1740s when watermills were running at less than peak efficiency. The population of the island also increased at this time and the Corn Laws led to increase in grain prices, so more grain was grown and needed to be ground.

The late eighteenth and early nineteenth centuries were the boom times of windmill building. However, increasing imports of foreign grain in the mid-nineteenth century led to price decreases, so many farmers converted their land to pasture for cattle and pigs, thus reducing the amount of grain that needed to be ground. Steam-powered milling on an industrial scale in the large ports such as Holyhead and Liverpool put further pressure on the ability of the local mills to compete and continue working. By the early twentieth century only a handful of mills were still limping along, with many powered by more reliable diesel engines rather than wind. The last working mill, Melin y Gof, closed in 1936.

Although all the current windmills were built from the mid-eighteenth century onwards, there are records of earlier windmills that are long gone. The accounts of the bailiff of Newborough state that a newly built windmill in Newborough began operation on 28 June 1303, after being built for £20, 12s 2½d (around £10,000 in today's money). In 1327 one was built on Mill Hill in Beaumaris, and another one was erected at an unknown location in 1495. In the sixteenth century the papers of the Baron Hill estate around Beaumaris twice mention windmills. Also on John Speed's 1610 map of

Melin y Bont, Llanfaelog, 1908.

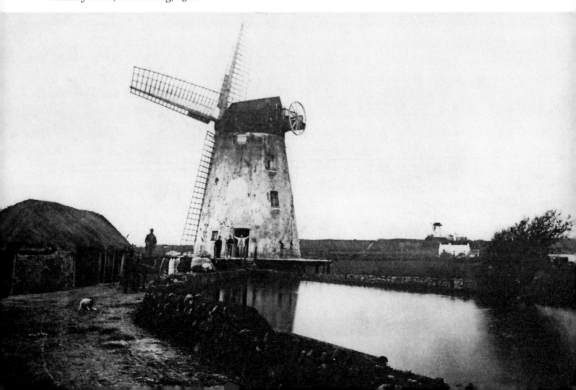

Anglesey the inset town plan of Beaumaris shows a windmill on the edge of the Menai Strait north-east from the castle. Whether this is one of the earlier mentioned mills is unclear, but it is unlikely to be the 1327 one as it isn't on a hill.

Out of the thirty-two windmills of which some of the structure still remains, fourteen have been converted into dwellings or incorporated into a larger house. Nine of these have been converted or renovated since 2000, showing the great increase of interest in restoring historic buildings.

Of the remaining mills one has been fully restored to working order (Melin Llynnon), one is a mobile phone mast (Melin Wynt y Craig), ten still stand to their full height (with three roofed), and six are partial towers or just the foundation. At least three of the empty towers have planning permission for future renovation.

As in the eighteenth and nineteenth centuries, our current age is also looking for new, alternative and sustainable sources of energy. We have again looked at the wind resources of Anglesey and found them very suitable, with the result that three wind farms have been built on the island. They are all in the north-west near the Irish Sea. Not only is it windy, but there is also a major existing power line in the area linking Wylfa nuclear power plant to the national grid.

Melin y Bont today.

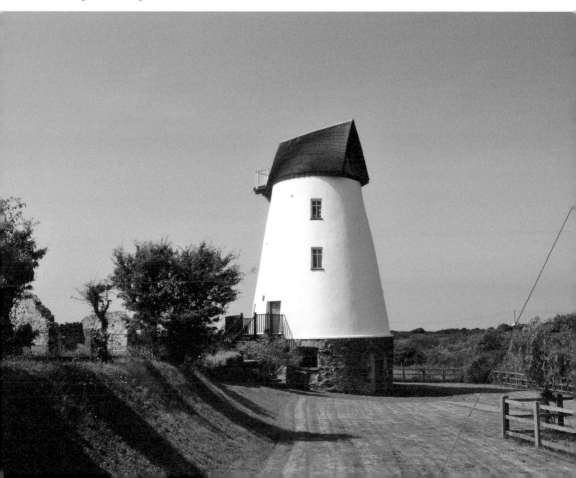

Melin Drylliau, near Rhyd-Wen, overlooking the Irish Sea.

The first to be built was Rhyd-y-Groes in 1992. It consists of twenty-four turbines, which produce 7.2 MW of power – enough for around 4,000 homes. In 1996 the Trysglwyn wind farm was opened with fourteen turbines producing 5.6 MW to power 3,000 homes, followed closely in 1997 by the thirty-four turbines of the Llyn Alaw site, producing a massive 20.4 MW for 11,000 homes.

The local council's 'Energy Island' strategy aims to supplement these in the future with sustainable tidal power, biomass processors and possibly a replacement nuclear plant for Wylfa, which closed in 2015. Planning applications for a large number of wind turbines around the island have been submitted, but these are now facing considerable opposition by those worried about the effects on tourism and property prices.

X – A Kiss for St Dwynwyn's Day

St Dwynwen is one of the most famous of Welsh saints. The patron saint of lovers in Wales, her feast day on 25 January is celebrated around the country, with an exchange of cards, gifts and special outings – in a similar way to St Valentine's. She lived during the fifth century AD and was one of twenty-four daughters of St Brychan, a Welsh prince of Brycheiniog (Brecon). She fell in love with a young man named Maelon, but rejected his advances. This, depending on which story you read, was either because she wished to remain chaste and become a nun or because her father wished her to marry another.

She prayed to be released from the unhappy love and dreamed that she was given a potion to do this; however, the potion turned Maelon to ice. She then prayed that she be granted three wishes: 1) that Maelon be revived, 2) that all true lovers find happiness, and 3) that she should never again wish to be married. She then retreated to the solitude of Llanddwyn Island to follow the life of a hermit.

Llanddwyn Church in the eighteenth century, from a specially illustrated edition of Thomas Pennant's *A Tour in Wales*, 1781. (Courtesy of the National Library of Wales)

Dwynwen became known as the patron saint of lovers and pilgrimages were made to her holy well on the island. It was said that the faithfulness of a lover could be divined through the movements of some eels that lived in the well. This was done by the woman first scattering breadcrumbs on the surface, then laying her handkerchief on the surface. If the eel disturbed it then her lover would be faithful.

Visitors would leave offerings at her shrine, and so popular was this place of pilgrimage that it became the richest in the area during Tudor times. This funded a substantial chapel that was built in the sixteenth century on the site of Dwynwen's original chapel. The ruins of this can still be seen today.

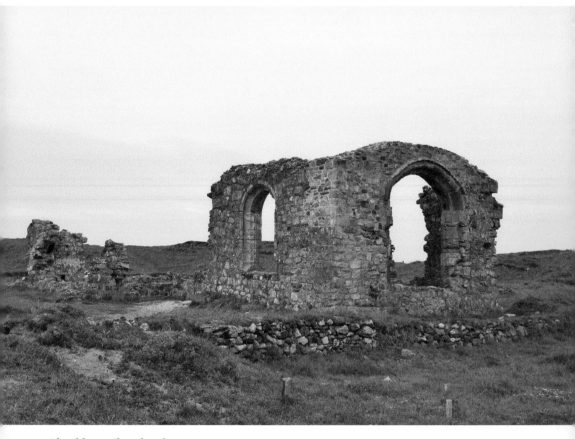

Llanddwyn Church today.

Y

Ynysoedd (Islands)

Welcome aboard the good ship *Ynys*. We are going on a tour around the coast of Anglesey to visit the smaller islands that encircle it. As we cast off from St George's Pier in Menai Bridge, we will turn to follow the strong tidal currents under the Menai Suspension Bridge and into the Swellies, where we will see the first of our islands.

Anglesey is surrounded by thirty-nine islands of various sizes, from small uninhabited rocks to the large and well-populated Ynys Gybi, or Holy Island. Several have buildings on them, and here we find two of them. Ynys Tysilio, or Church Island, is connected to the mainland by a causeway. Here is the church of St Tysilio. Founded by Tysilio, the son of Brochfael Ysgythrog, king of Powys, it was his place of hermitage around AD 630. The current building dates from the fifteenth century, with extensive refurbishments in the 1890s. Originally half of the island was devoted to the church and churchyard, with the other half being a farm, but after 1918 the whole island was given to the church.

Church Island, with the causeway to the left, and the Britannia Bridge and Ynys Gorad Goch in the distance on the right.

Ynys Gorad Goch, showing one of the two curved walls of the fish trap (the other is on the far side, behind the smokery building on the left).

Before we pass under the Britannia Bridge we will see Ynys Gorad Goch ('the island of red weirs'). The weirs here are fish traps, walls built in tidal waters to trap fish as the tide goes out. It is thought that these traps were first used in the thirteenth century to supply fish to the local monasteries, and papers dating back to 1590 show it being owned by the diocese of Bangor. The buildings are from at least the early nineteenth century and are often flooded during high tides. In the early twentieth century the island was a place for tourists to take a boat trip to for 'whitebait teas', a meal of tea, brown bread and fried whitebait fish – all for a shilling.

We exit the Menai Strait past Aber Menai Point and turn west toward Ynys Llanddwyn. This magical island hosts two lighthouses and St Dwynwyn's Church, described in chapters L – Lighthouses and X – A kiss for St Dwynwyn's Day, as well as the interesting geology mentioned in chapter G – Geology. Continuing on we reach Cribinau, the site of St Cwyfan's church (popularly known as the Church in the Sea). This 14th century church stands at the end of what was once a peninsula, but the waves slowly eroded it away. The church itself was threatened as graves began to fall into the sea, but in 1893 local architect Harold Hughes led a drive to construct a wall around the island to shore it up, and restore the church.

We next reach Ynys Gybi, the largest island hosting the town of Holyhead as well as the popular seaside villages of Trearddur and Rhoscolyn. It has several of its own satellite islands, including Ynys Lawd, the site of the South Stack lighthouse (described in chapter L – Lighthouses) and Ynys Arw, home of the North Stack foghorn station. In the heart of the Holyhead port is Ynys Halen, Salt Island, with several piers, the old lifeboat station, and the 19th century trio of the Customs House, Harbourmaster's House, and Admiralty Arch.

Heading north we can see Ynysoedd y Moelrhoniaid (The Skerries) 3 km in the distance. The lighthouse here, described in chapter L – Lighthouses, warns sailors

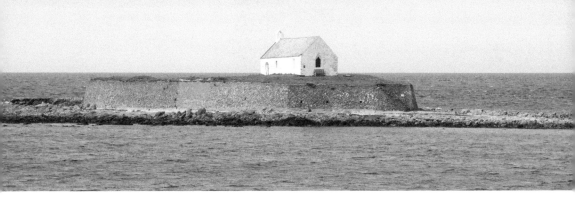

Cribinau and St Cwyfan's church. The tidally exposed causeway to the mainland is to the right.

rounding the corner of Anglesey on the way to Liverpool. Along the north coast we pass three small rocks, known in English as the West, Middle and East Mouse islands. The middle one, also known as Ynys Badrig, is reputed to be the place where the Irish patron saint, St Patrick, was shipwrecked. He survived, made it to shore, and founded the church of St Badrig in thanks.

Further on is Ynys Dulas, at the mouth of Dulas Bay. A tower stands on the rock, built in 1821 by Colonel James Hughes of Llys Dulas Manor. His concern for sailors who were often shipwrecked off this coast led him to build it to provide a landmark as well as shelter until they were rescued; it was regularly stocked with food and water.

As we round the eastern corner of Anglesey we see Puffin Island. Named in English after its puffin colonies, it is also known as Ynys Seiriol, after the saint who founded the nearby priory at Penmon, and by the Viking name Priestholm. In later life Seiriol set up a hermitage on the island, where the ruins of its later buildings still exist. A telegraph station was established on the island in 1827 to relay signals about shipping between Holyhead and Liverpool. In 1887 the telegraph building was converted into a marine biological station by the Liverpool Marine Biology Committee, one of the earliest stations in the UK. It was abandoned in 1897 and has since fallen into ruin.

Llanbadrig Church, with Ynys Badrig/Middle Mouse in the distance.

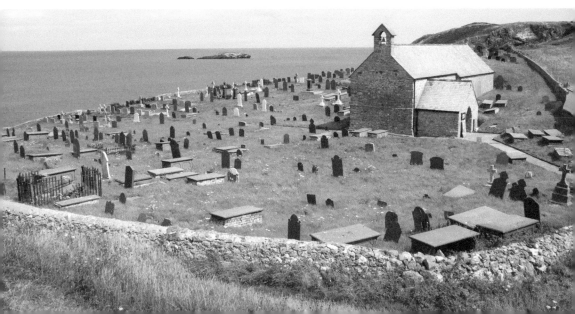

Zoos

Although Anglesey is teeming with natural wildlife wonders (see Nature Reserves, page 52), it also offers alternative animal experiences. Several visitor attractions around the island allow visitors to get up close to animals that are either hidden from regular view, normally seen across a field, or come from more exotic places.

In the 1970s Bangor University graduates David and Alison Lea-Wilson began a business selling game and seafood locally to hotels and restaurants. As part of their business they were raising oysters and keeping live lobsters in tanks, along with some other unusual fish that the lobster fishermen had caught incidentally. Local people

The Big Fish Forest at Anglesey Sea Zoo.

started coming around just to have a look at the creatures, and the Lea-Wilsons started creating more naturalistic tanks for them, eventually charging people to visit. It formally became the Anglesey Sea Zoo in 1983.

The Sea Zoo has grown over the years into Wales' largest marine aquarium. It focuses on the sea life found around the British coast, and particularly off of Anglesey. Its forty tanks house over sixty species, including lobsters and crabs, seahorses, sharks and rays and fish like sea bass, bream, plaice and turbot. Two tanks simulate the crashing waves that are a vital part of the environment along our coast, while another recreates a shipwreck, inhabited by various fish including the conger eel. Most magnificent is the Big Fish Forest, a huge tank with a curved glass wall at one end that allows you to stand in the middle of a kelp forest while bass, bream and wrasse swim around you.

Although the attraction is a fun place to view these seldom seen animals, a major and important part of its work is conservation. Its origins as a lobster reseller meant

Long-snouted seahorse (*Hippocampus guttulatus*) at Anglesey Sea Zoo. (Courtesy of Anglesey Sea Zoo/Paul Kay)

that from the early days efforts were made to breed and raise juvenile lobsters for later release back into the nearby Menai Strait, to supplement dwindling stocks. Visitors have always enjoyed seeing the water-filled trays containing tiny lobsters at various stages of growth. To date over 3,000 lobsters have been released. The Sea Zoo is also involved in the breeding of seahorses, in conjunction with aquaria around the UK and Europe, to help save species that are threatened in their native habitats.

Alongside the Sea Zoo, the Lea-Wilsons began experimenting with creating sea salt from the vast quantities of water that they were licensed to use for the aquarium. This business, Halen Môn, has grown to world-wide fame, and the Lea-Wilsons sold the Sea Zoo in 2007 to concentrate on the salt.

The new owner, Frankie Hobro, had regularly visited the Sea Zoo as a child and later became involved in conservation projects around the world, including Mauritius, Madagascar, Zambia, New Zealand and the Maldives. She has increased the existing conservation efforts at the zoo and also made the zoo a link in a marine animal rescue network, that saves sick or stranded marine animals. In 2016 the Sea Zoo made headlines around the country after a rare Olive Ridley turtle was washed up on the shore just by the zoo, 8,000 miles from its usual home in the southern Atlantic. After caring for the turtle, nicknamed Menai, for eight months it was flown to a rescue centre in the warmer climate of Gran Canaria to prepare for release. Unfortunately, after a few weeks there her condition deteriorated, and she died.

Clipper butterfly (*Parthenos sylvia*) at Pili Palas.

We can move up out of the watery realms and head to our next zoo, Pili Palas. The Welsh word for butterfly is *pili pala*, and palace is *palas*, so the founder's play on words give this attraction full of butterflies its name. In the 1980s, teacher, children's book author and part-time minister Huw John Hughes wanted to turn his teaching experience and interest in tourism into something that would be both educational and fun for children. As a student he had worked on a butterfly farm in Dorset, and had always wanted to set up a similar venture. He teamed up with partners with retail and catering experience and in 1985 opened Pili Palas.

Its greenhouse full of tropical plants and water features originally housed just a wide variety of butterflies, flying free throughout the house, creating a magical atmosphere. Over the years more houses were added to accommodate a number of birds and tanks with snakes, lizards and spiders. A pet corner and an educational centre were also included.

In 2005 Revd Hughes decided to concentrate on his children's writing and sold the zoo to Gwawr and Steve Bell. They've expanded the zoo to include play areas and a variety of mammals such as donkeys, alpacas and the ever-popular meerkats. In July 2019 they decided to retire and the attraction is up for sale at the time of writing.

Close to the Anglesey Sea Zoo is Foel Farm Park. Not a zoo in the traditional sense, this is instead a family oriented attraction on a working farm. In 1991 farmer Bevis Spears decided to diversify and started welcoming visitors to tour the farm and meet the animals. Visitors can help feed the animals, including bottle feeding newborn lambs and calves in the spring. Tours around the farm are done on a tractor-drawn trailer or the more exciting quad-bike-drawn trailers.

Finally we can stop by what could be called a 'dead zoo'. Opened in 1989 by geologist Dave Wilson to show off his extensive collection of rocks and fossils, Stone Science is a place to learn about extinct animals and plants as well as stones and minerals. A series of dioramas show what these extinct organisms would have looked like in life, alongside real dinosaur fossils. A well-stocked shop lets you take home your own fossilised fish or trilobite.

Acknowledgements

I'd like to thank the following for their help in researching this book and for providing images and photographs: Gwasg Gregynog, Frankie Hobro/Anglesey Sea Zoo, Hywel Meredydd Davies/Cape Cildwrn, John Cowell and Menai Heritage. I'd particularly like to thank my wife, Catherine Duigan, for her help and encouragement in writing this book.

All modern photos were taken by me, except where otherwise noted. Uncredited older photographs are from my collections. Every attempt has been made to seek permission for copyright material used in this book. However, if we have inadvertently used copyright material without permission/acknowledgement we apologise and will make the necessary correction at the first opportunity.

About the Author

Warren Kovach is the author of the popular anglesey-history.co.uk website, which highlights aspects of the island's history, supplemented by many of his own photographs. He has also written two previous books for Amberley, *Anglesey Through Time* and *Anglesey in 50 Buildings*.

Born and raised in Ohio, USA, he moved to Anglesey in the early 1990s and soon set about exploring its history and landscape. He has a PhD as a researcher in biology, ecology and palaeontology, but later moved to developing scientific computer software. He is a keen photographer and has had his photos published in many national newspapers, books and magazines around the world.

You can follow him on Twitter at @AngleseyHist or on the 'Anglesey History' Facebook page.